ET TT SNOW

"The snow doesn't give a soft white damn whom it touches."

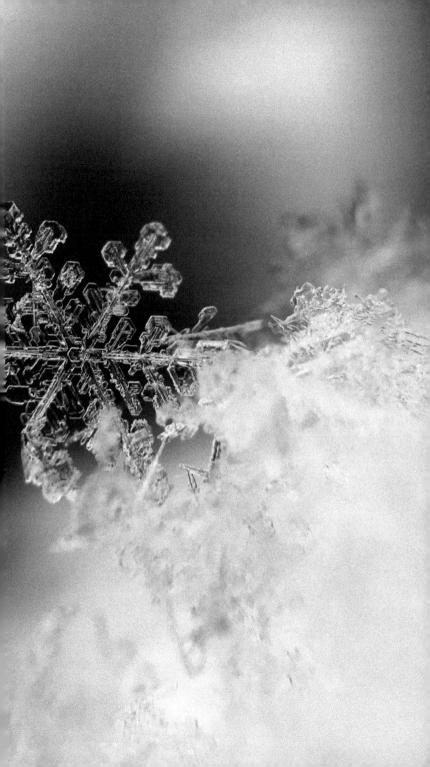

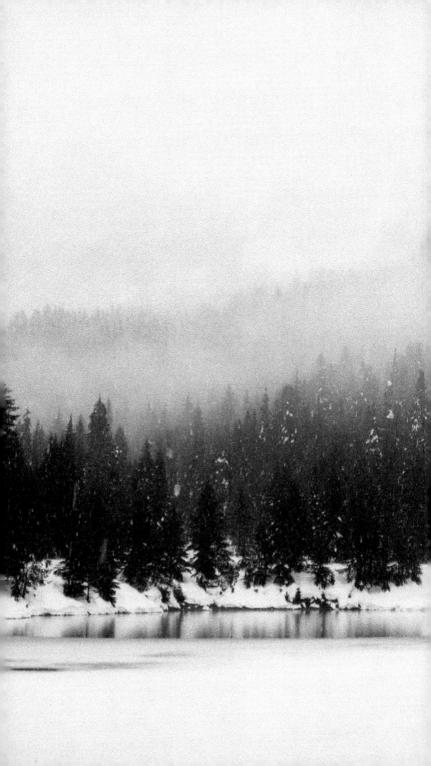

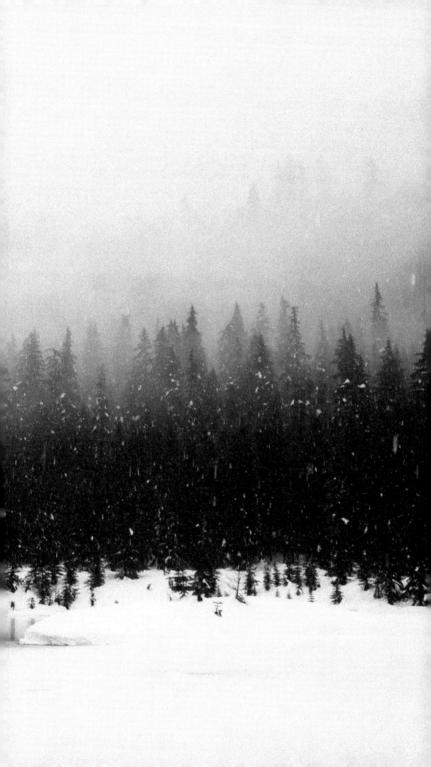

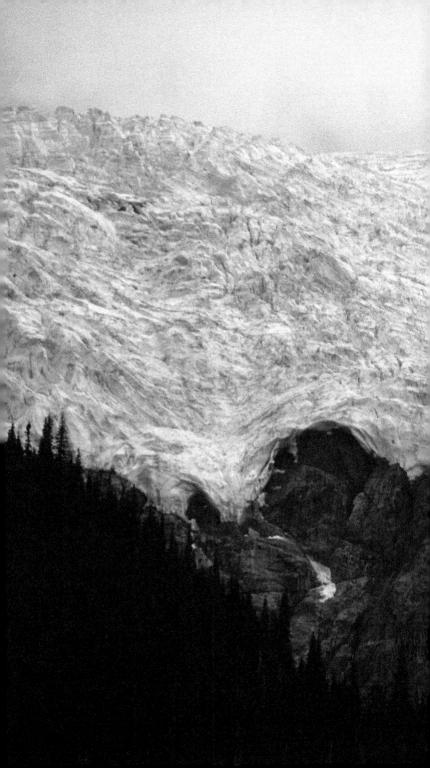

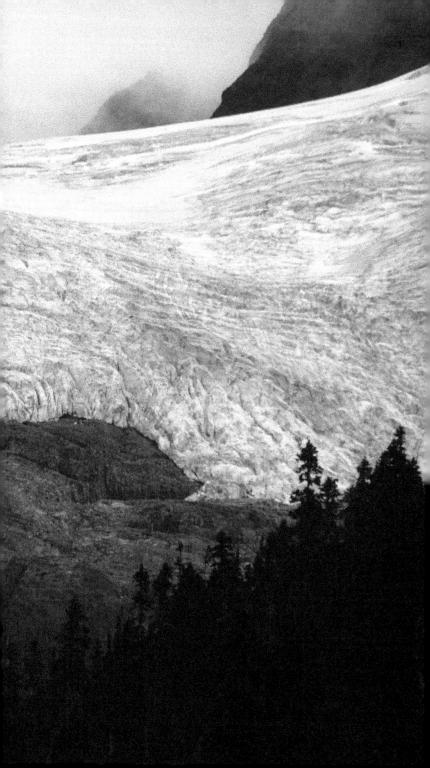

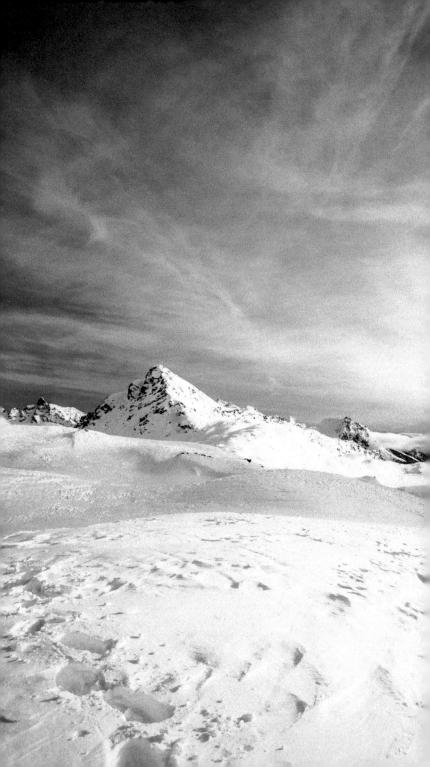

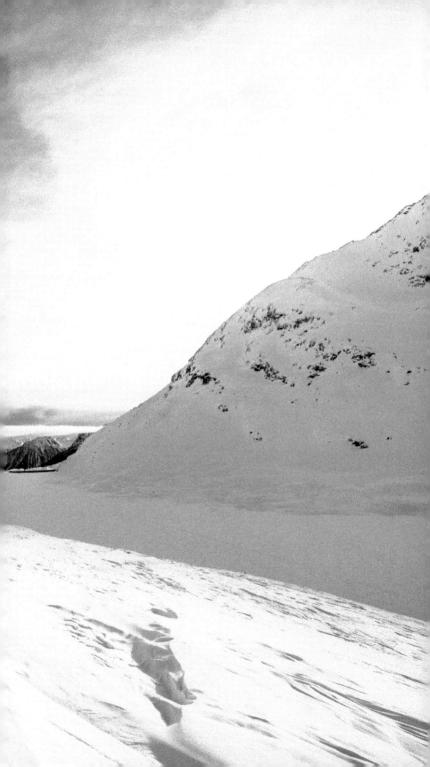

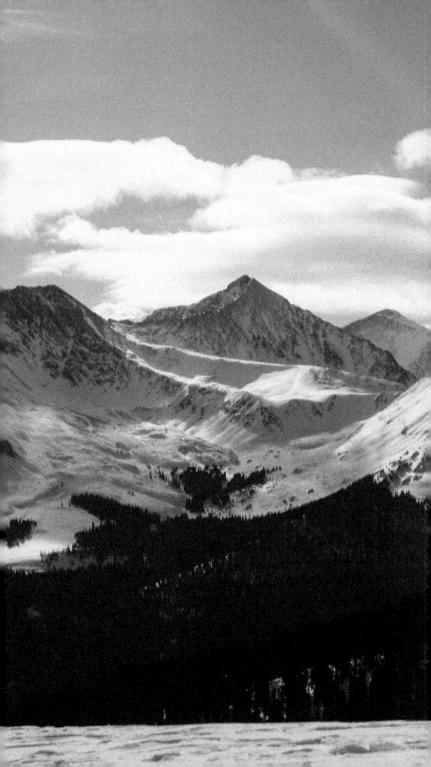

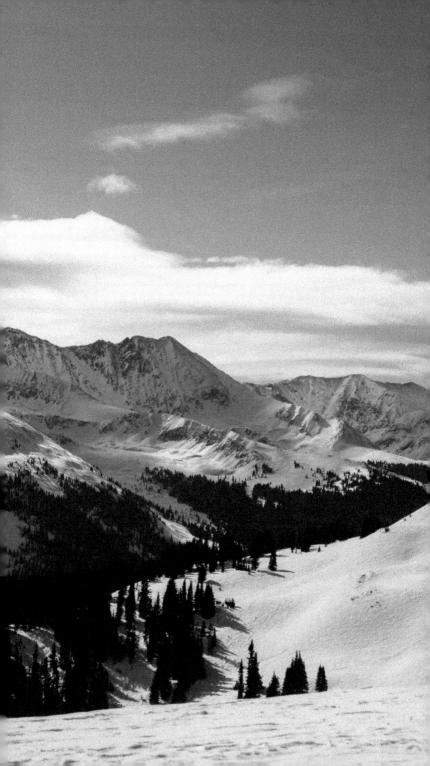

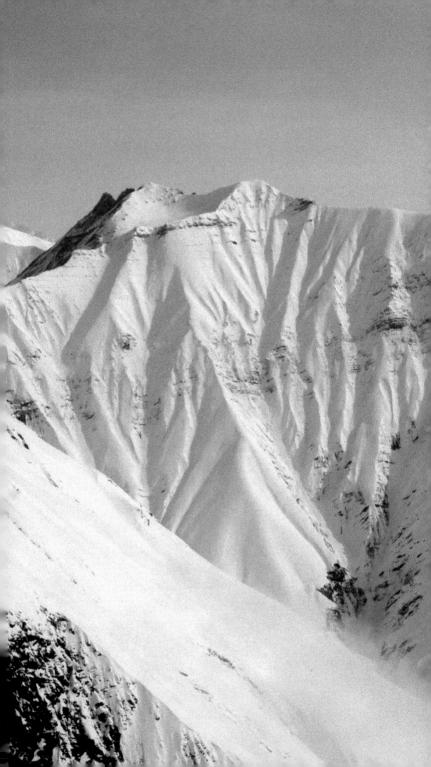

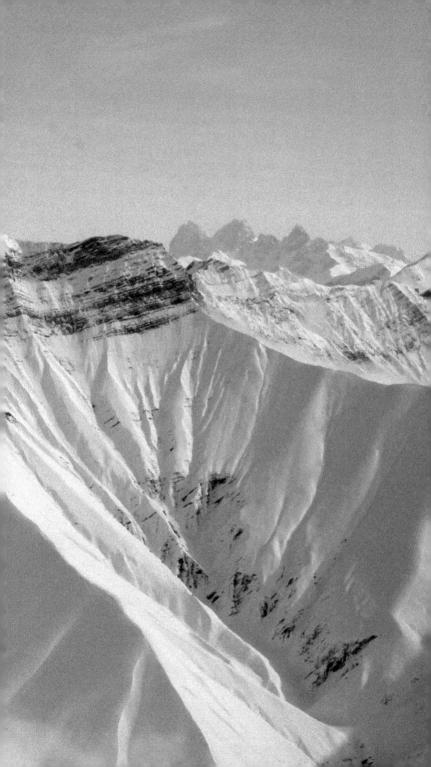

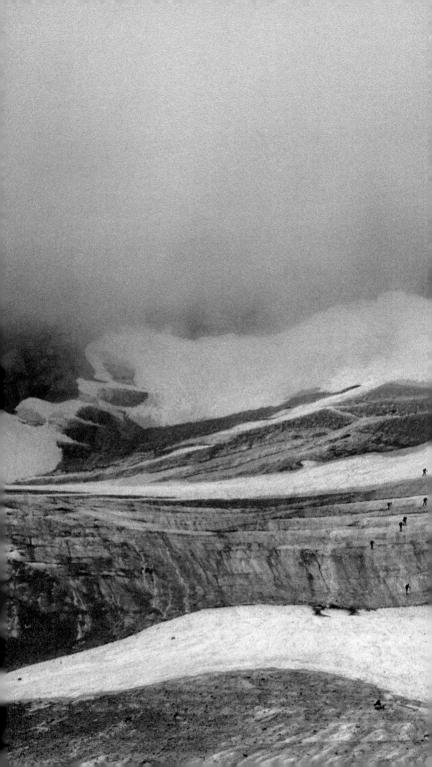

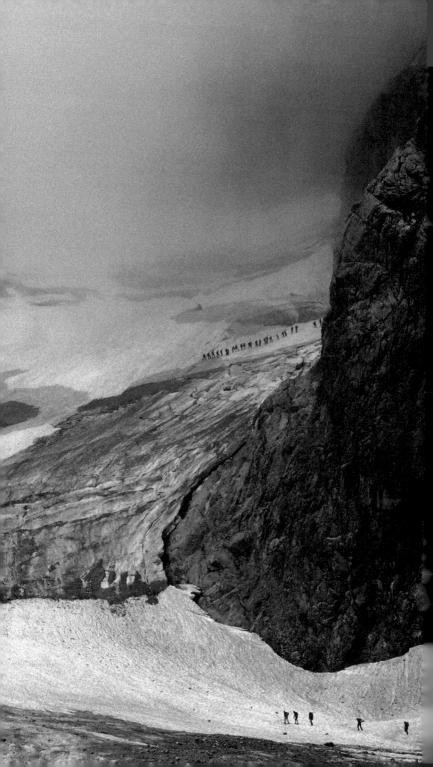

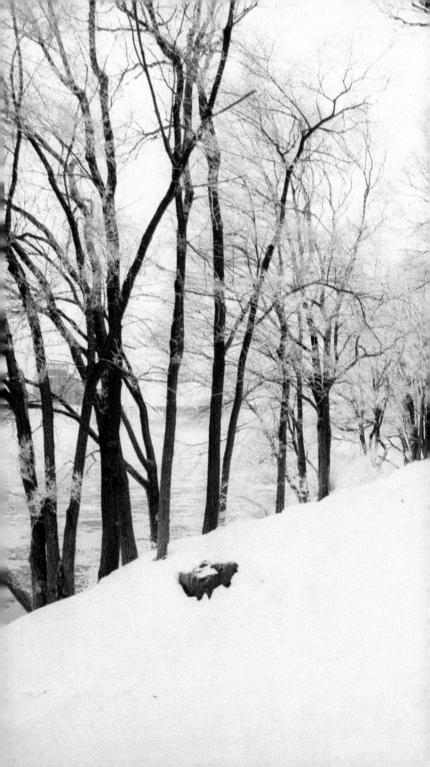

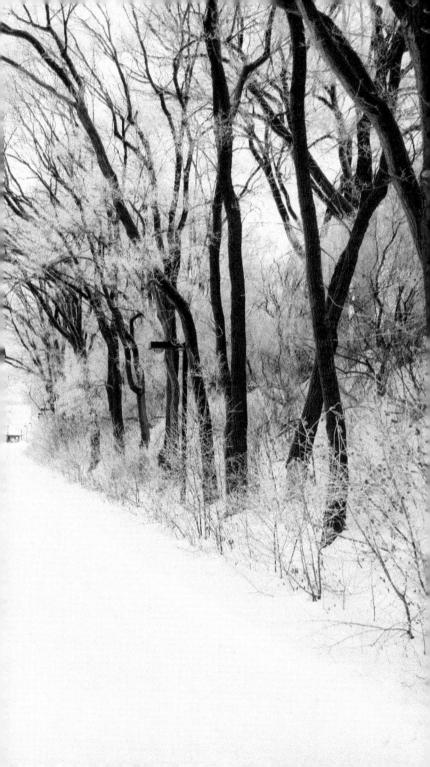

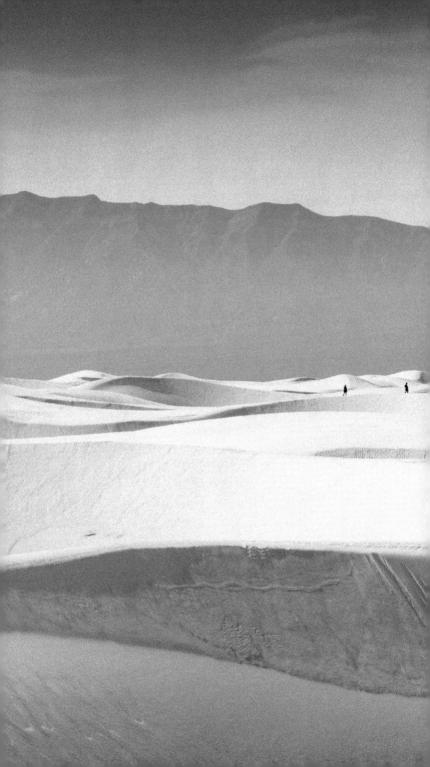

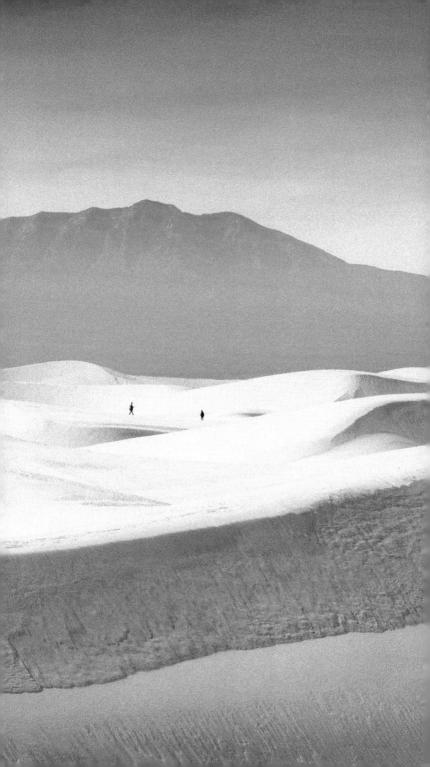

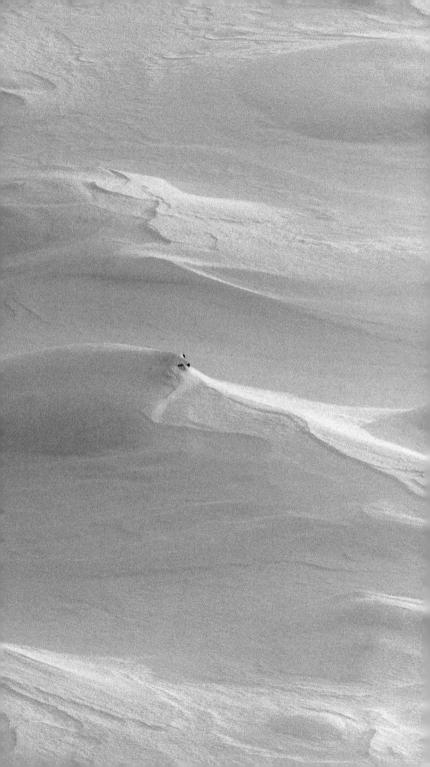

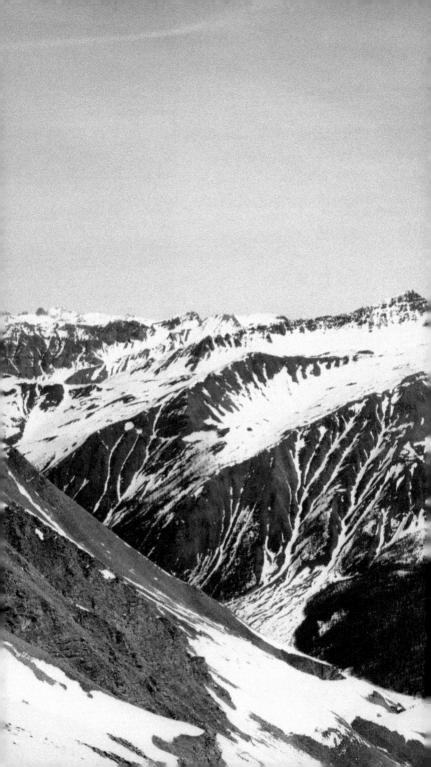

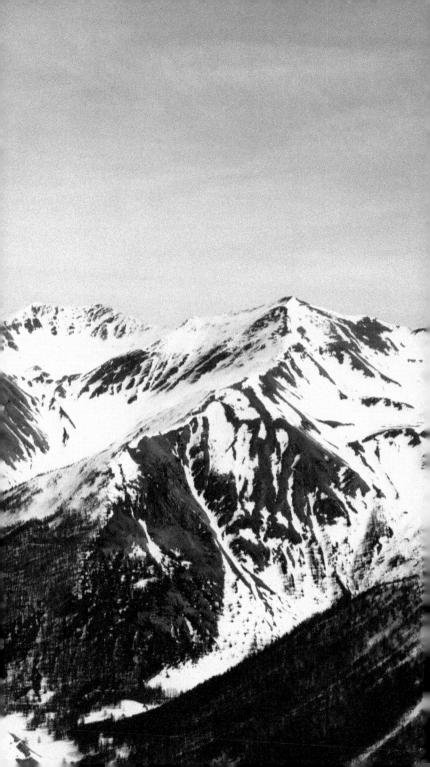

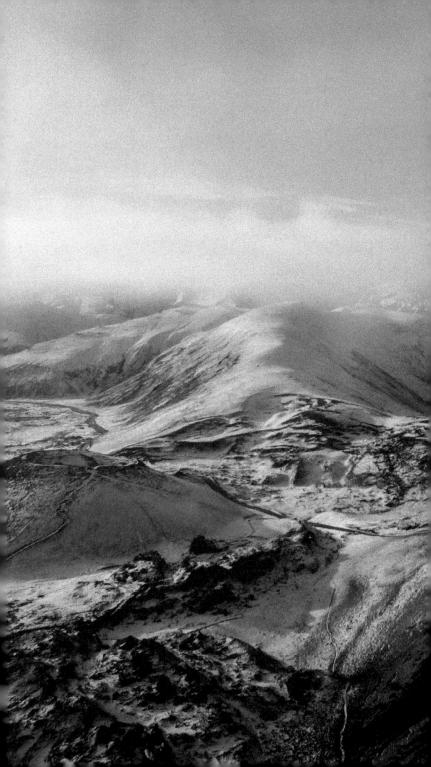

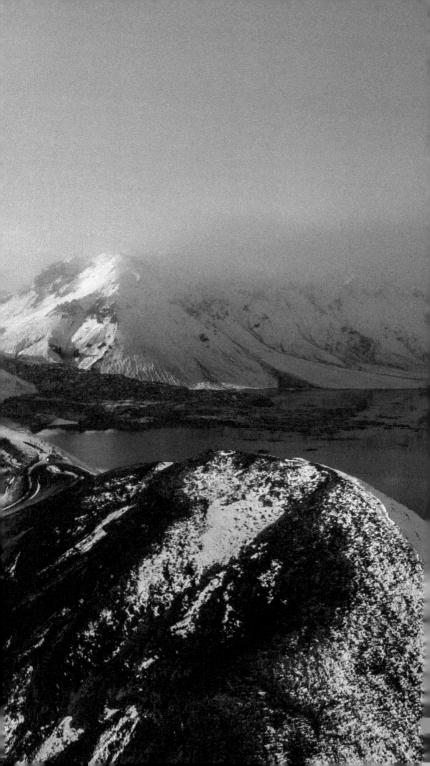

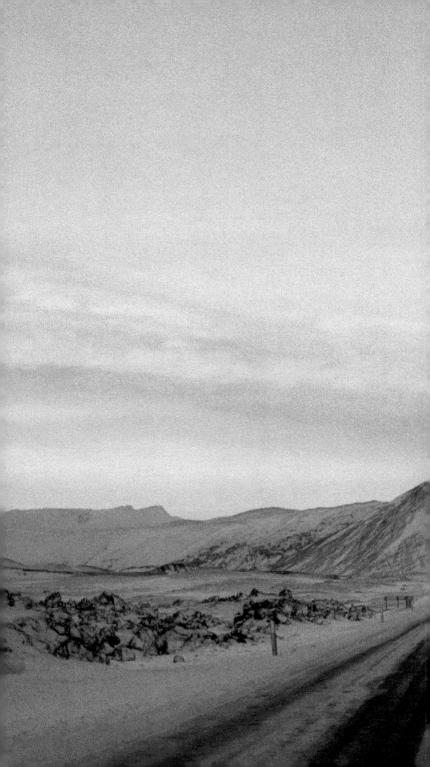

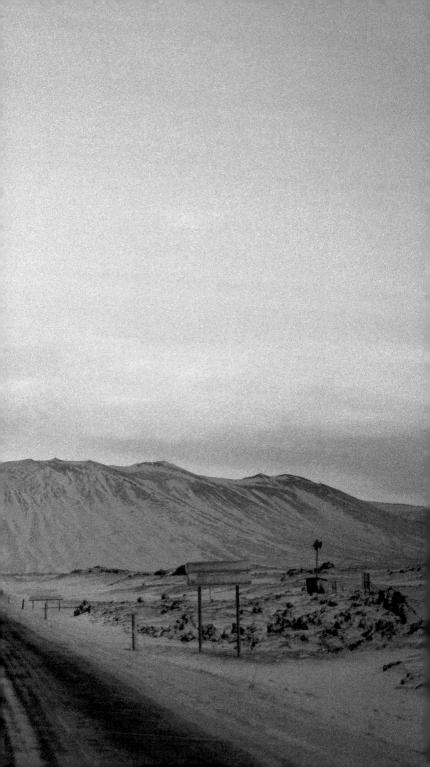

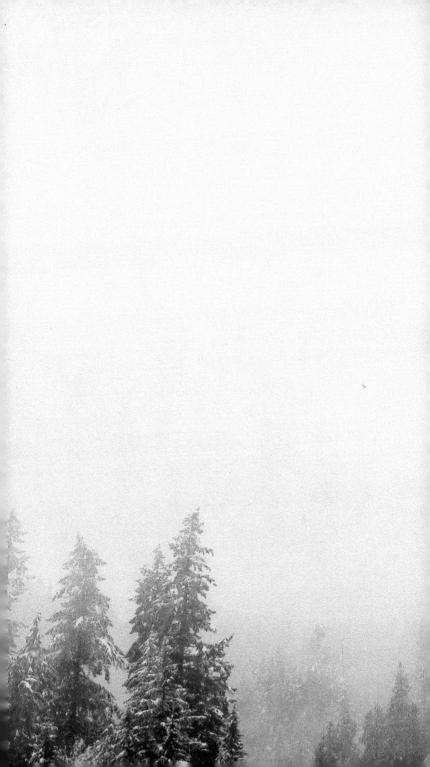

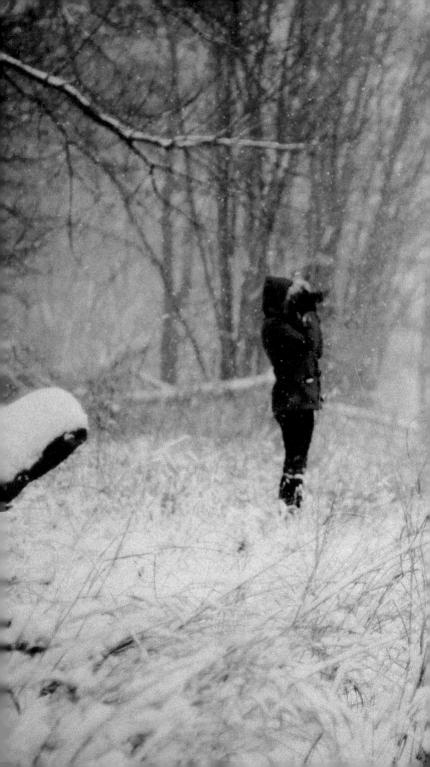

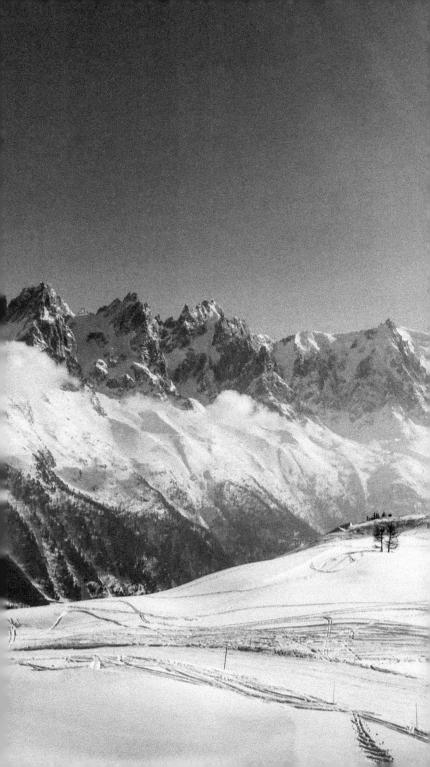

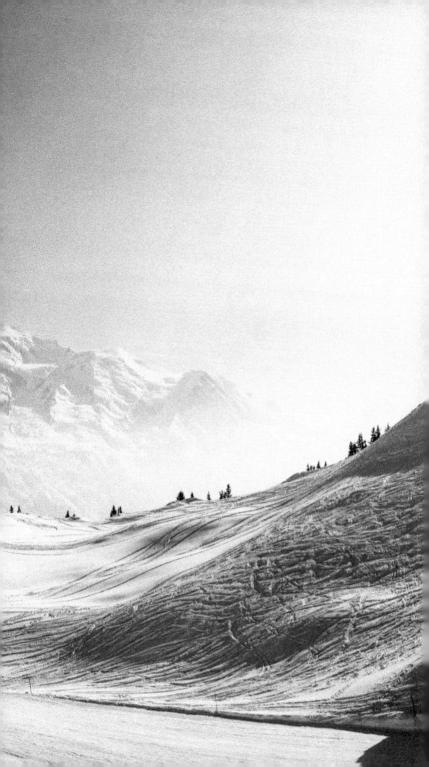

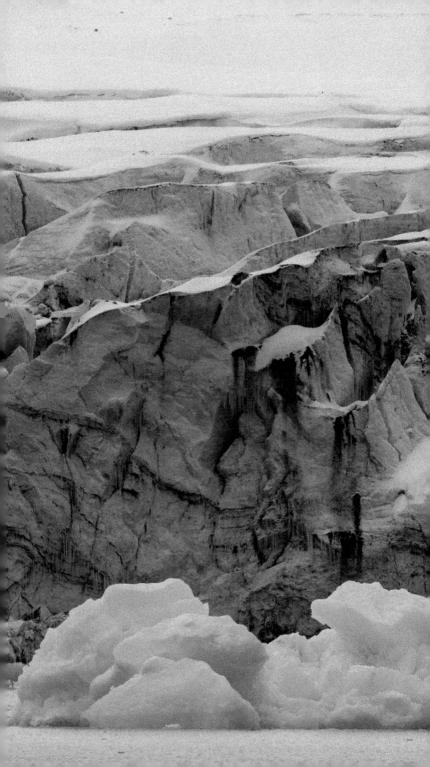

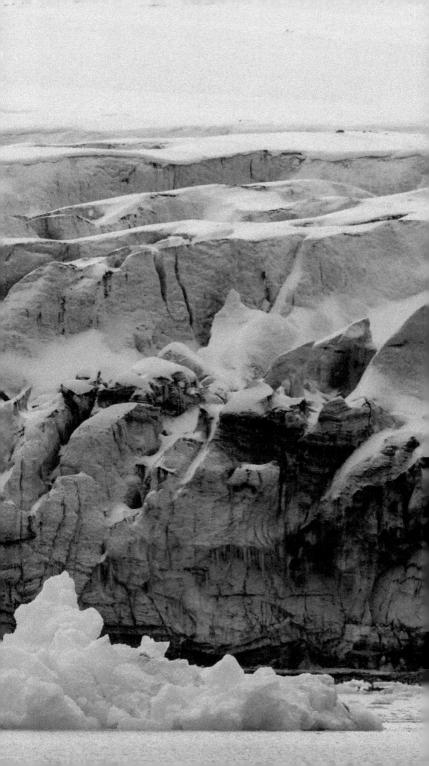

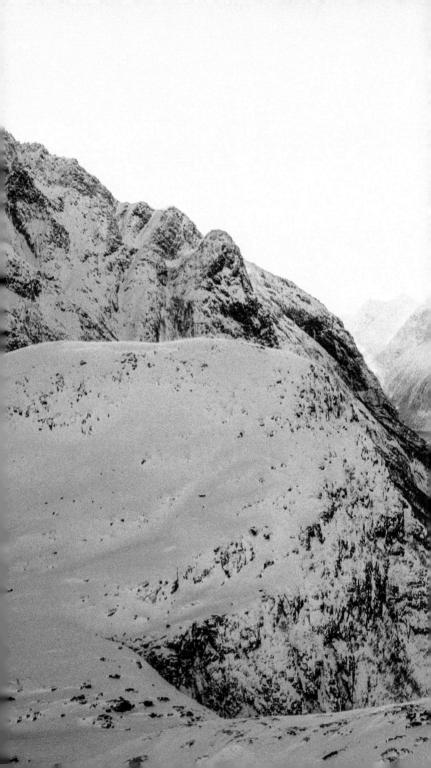

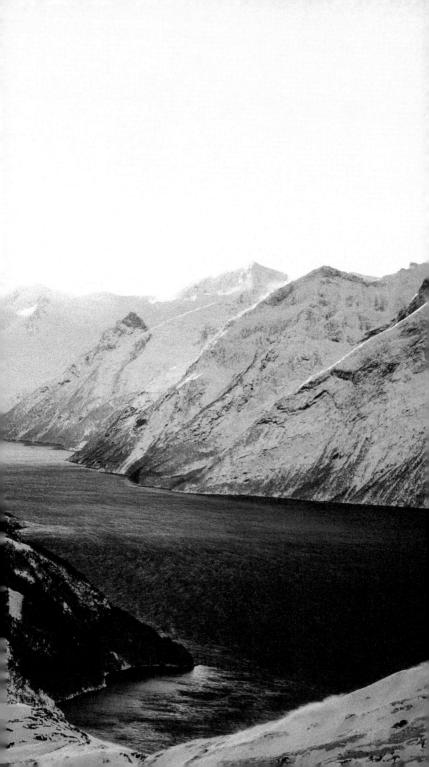

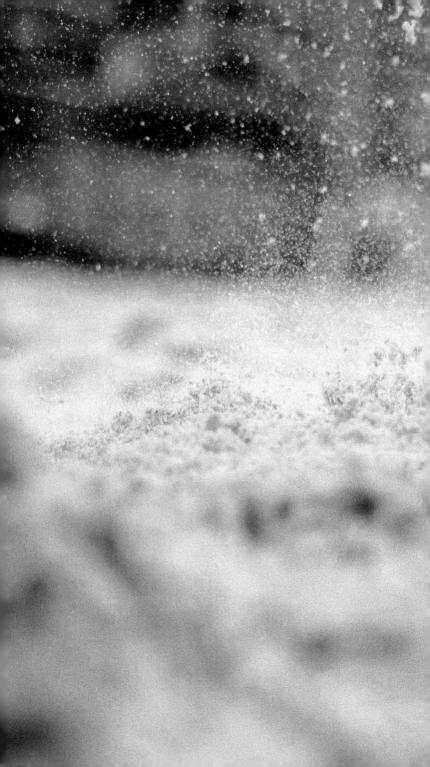

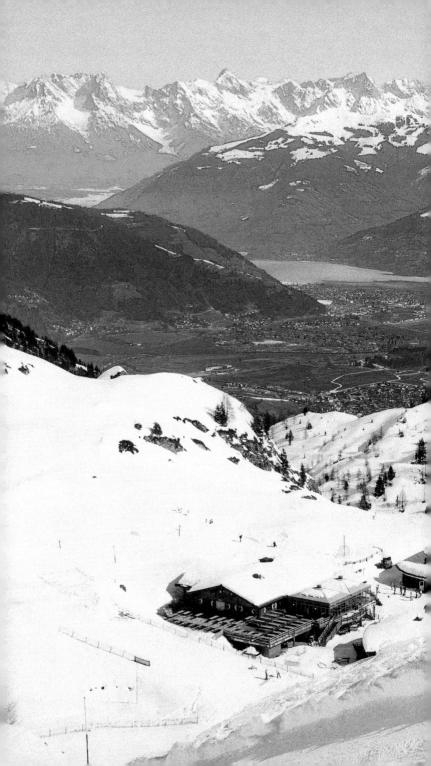

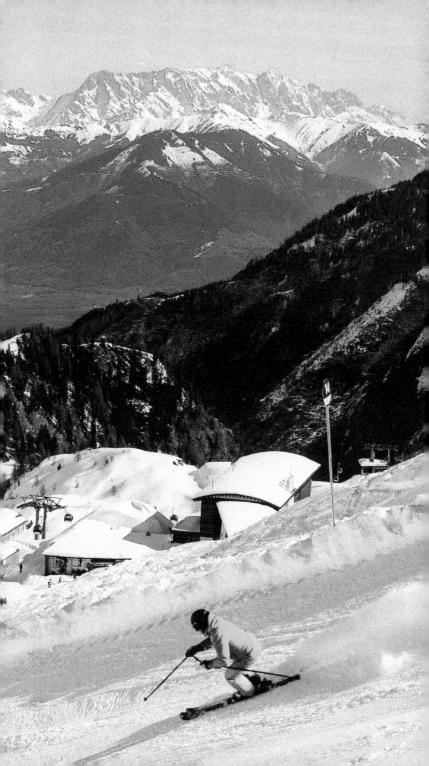

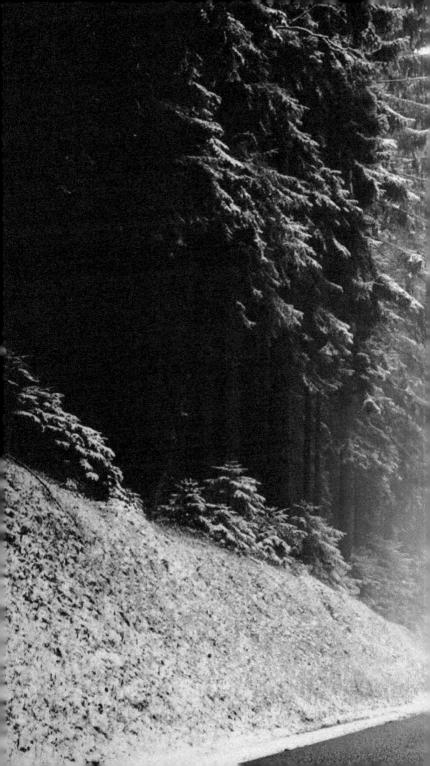

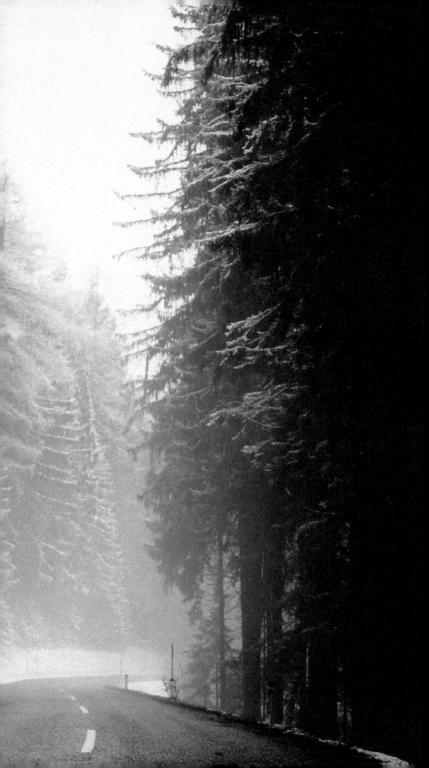

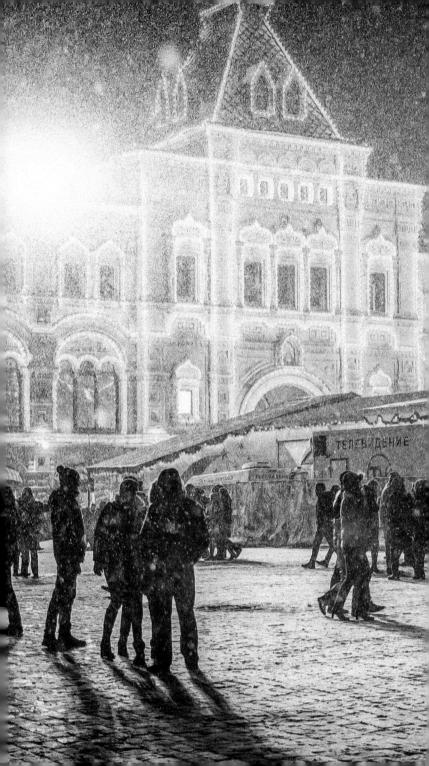

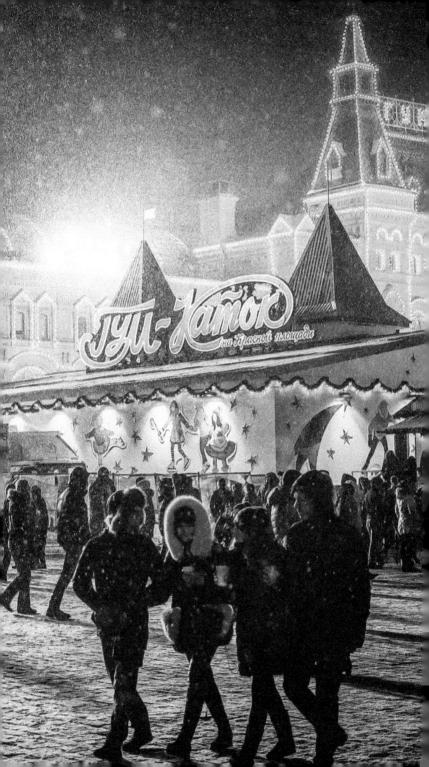

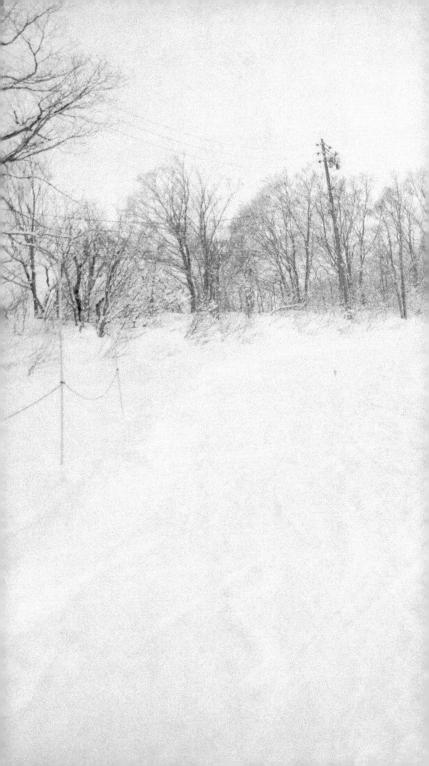

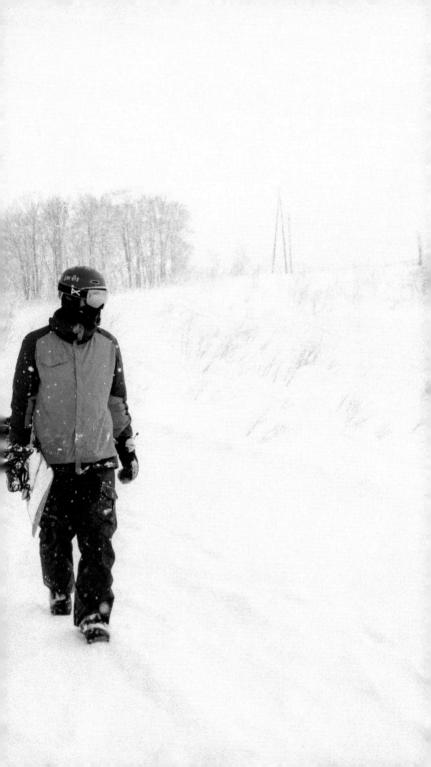

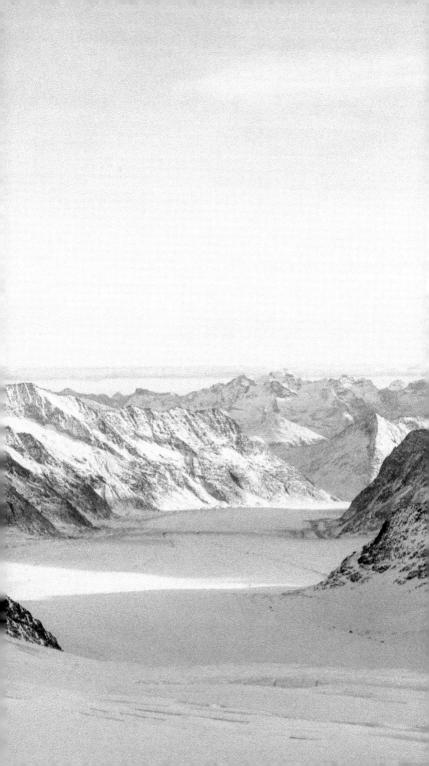

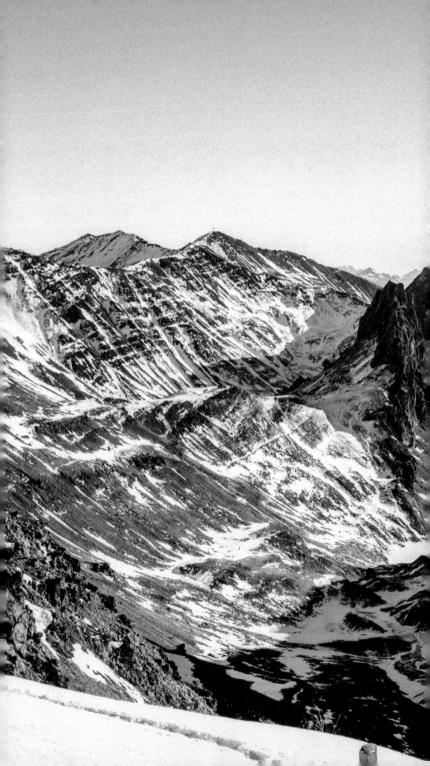

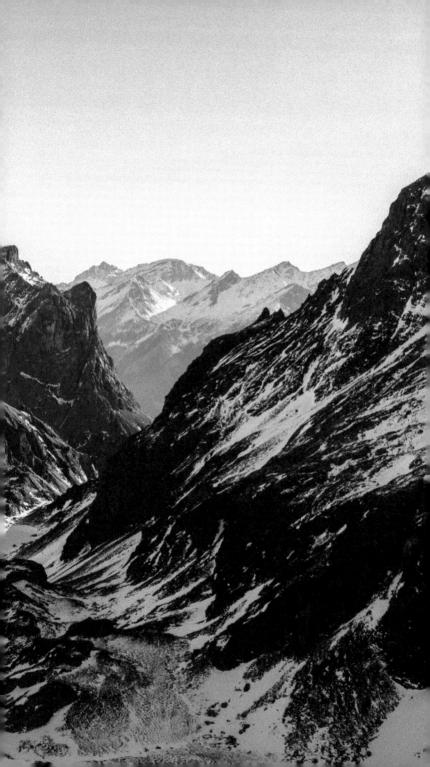

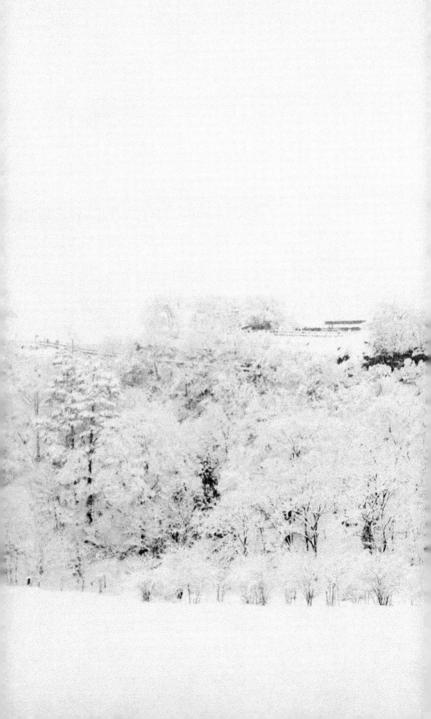

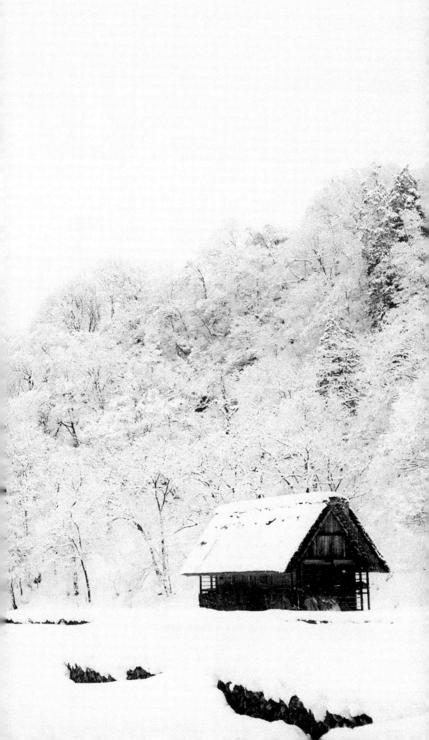

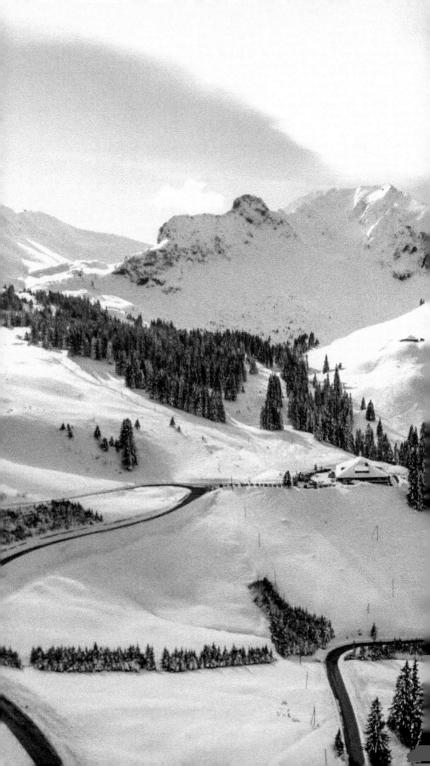

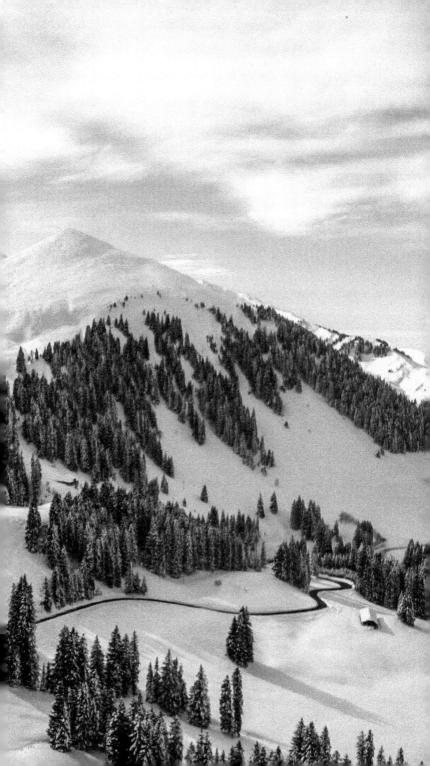

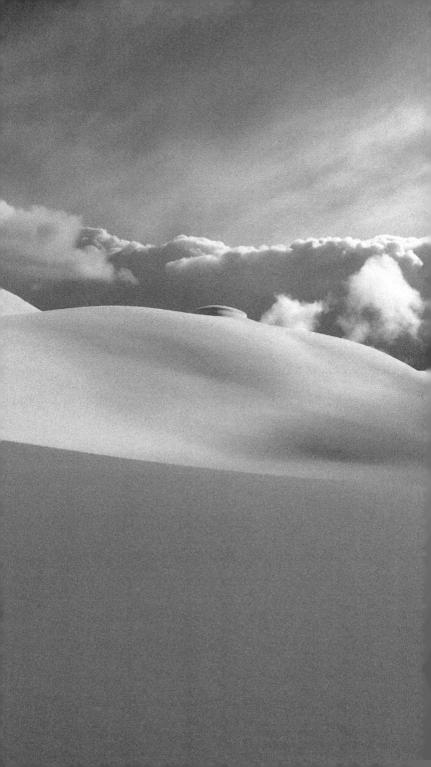

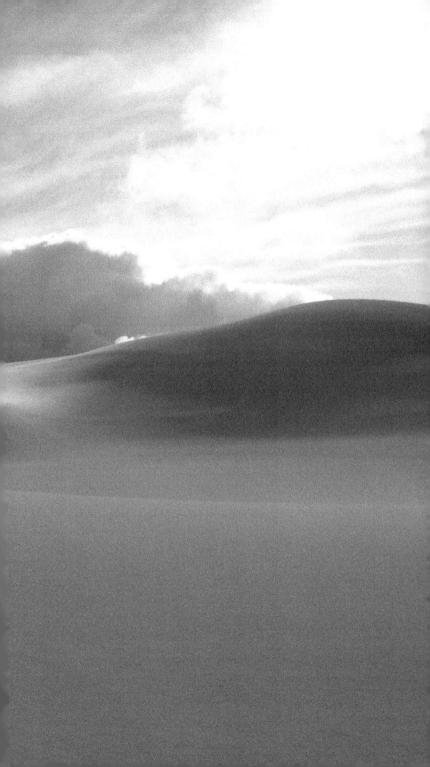

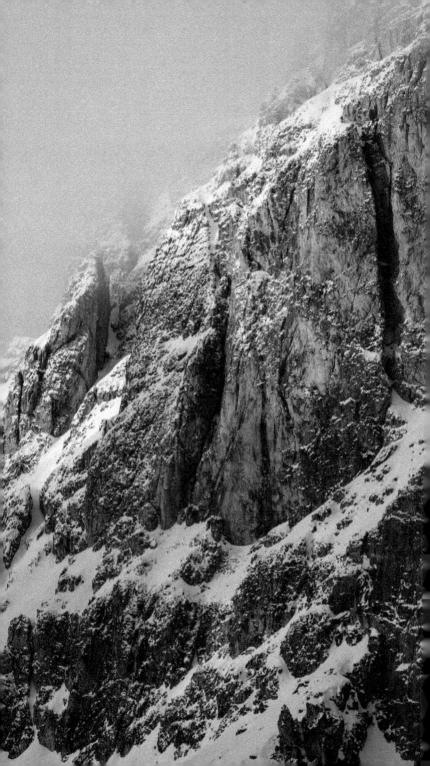

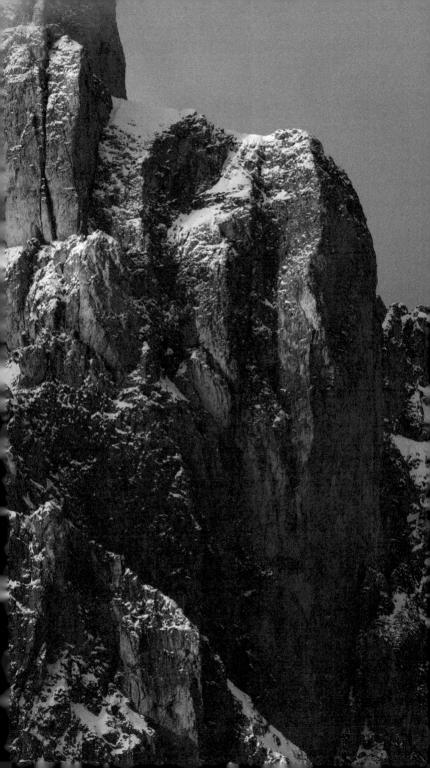

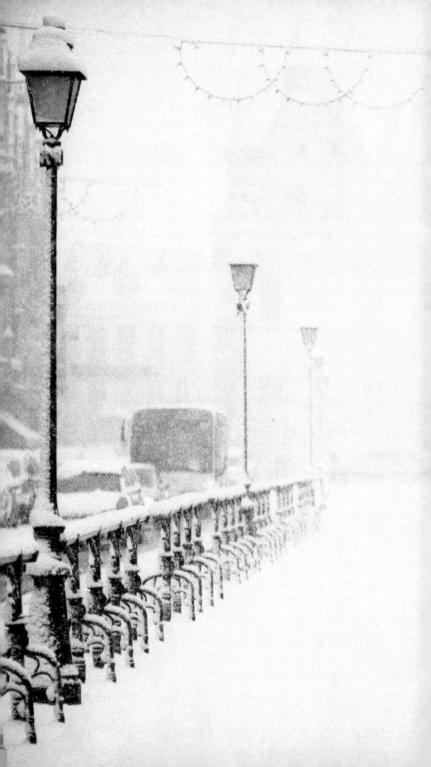

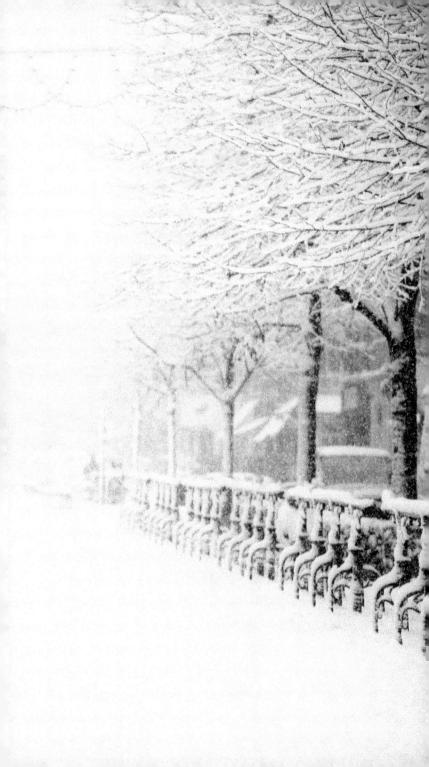

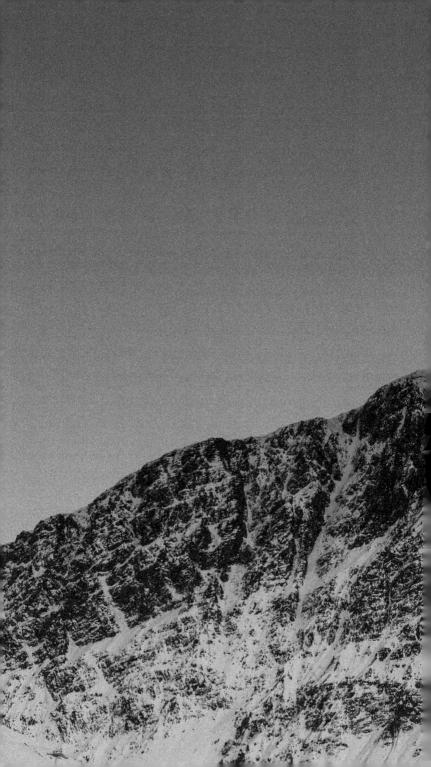

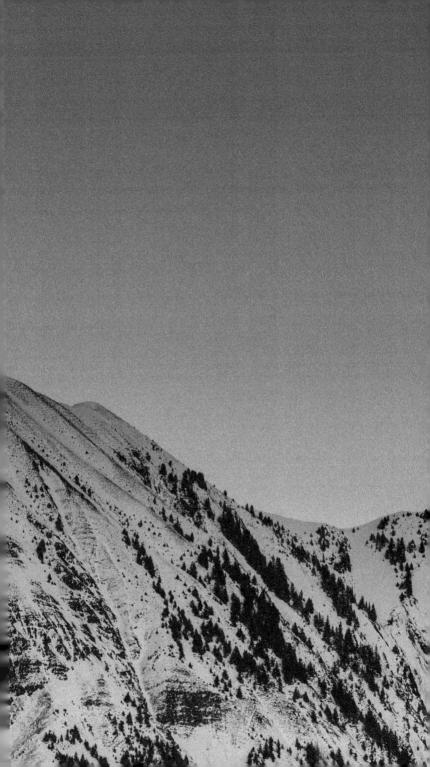

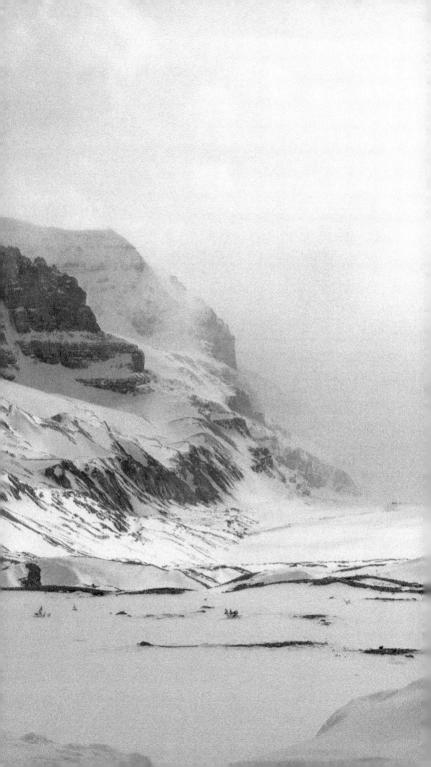

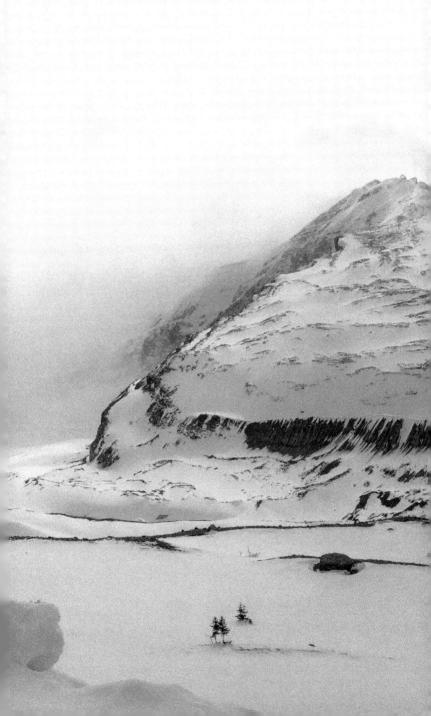

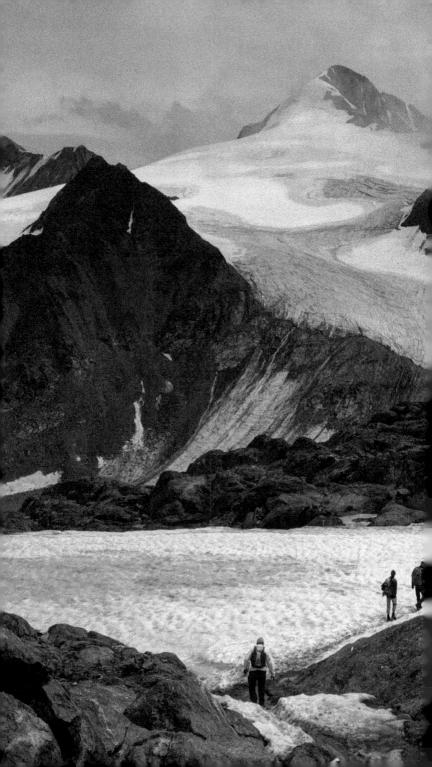

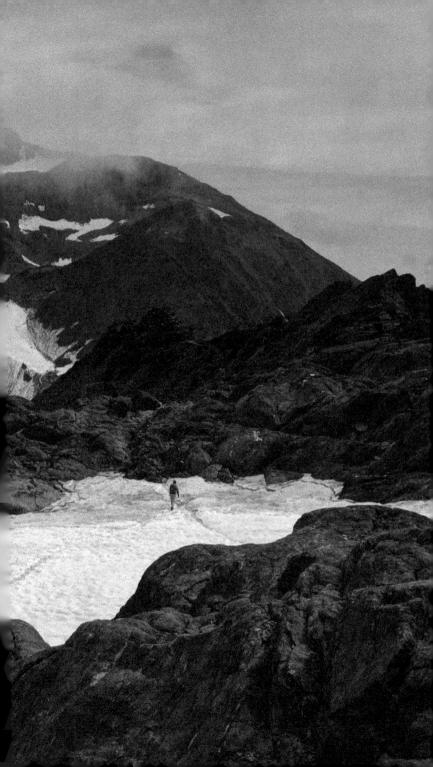

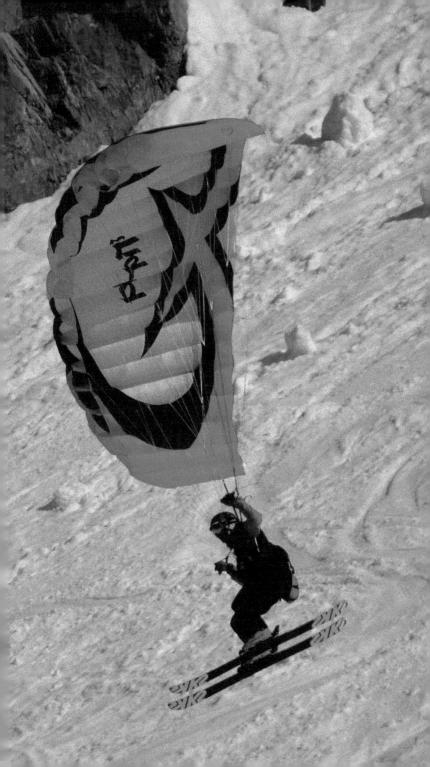

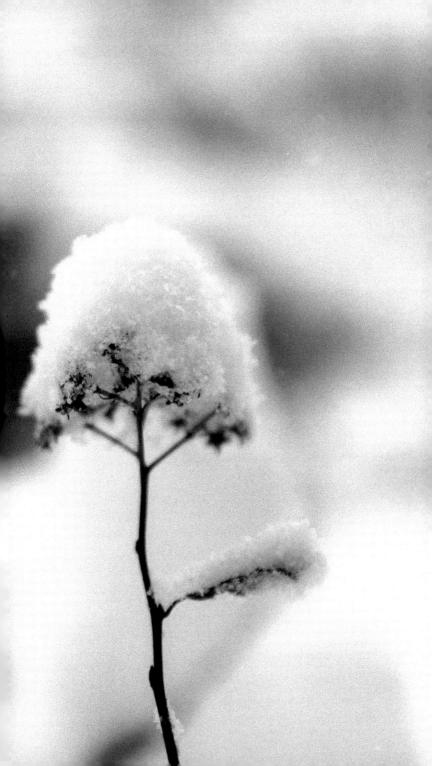

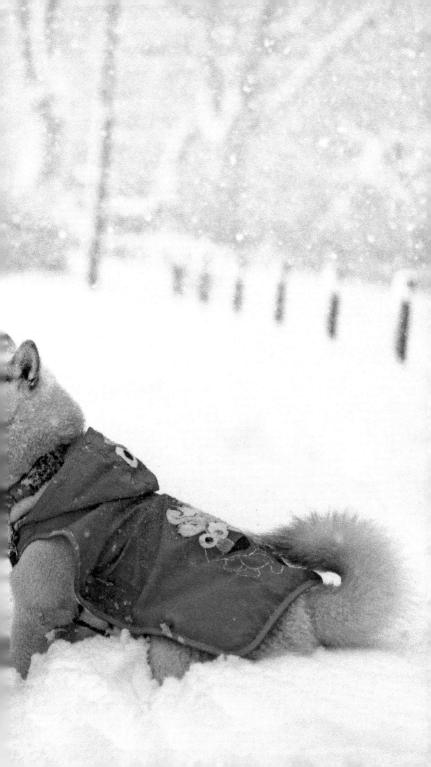

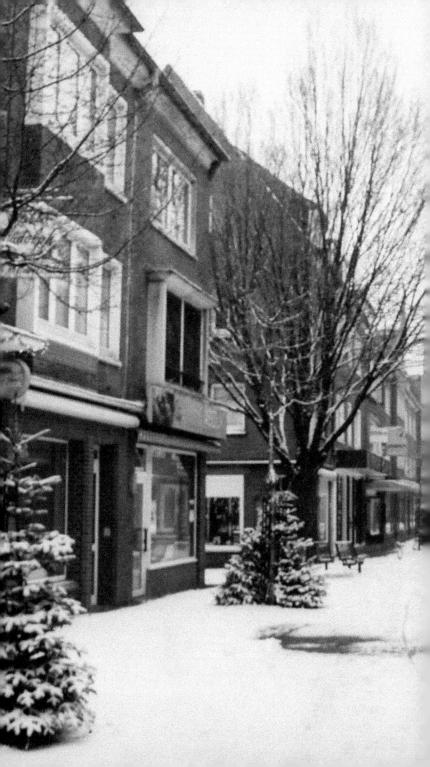

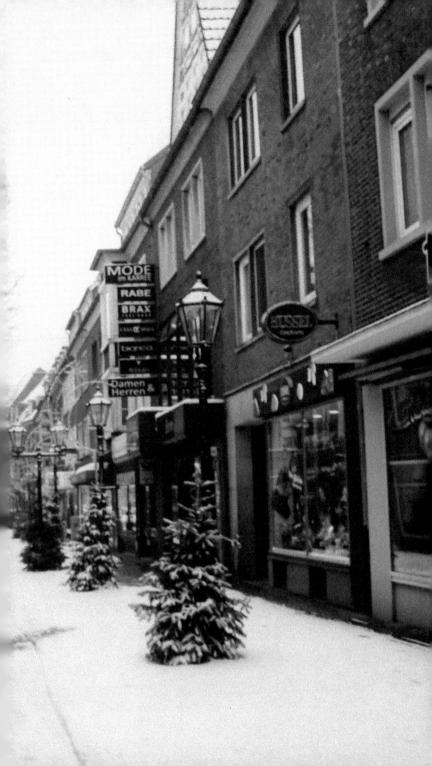

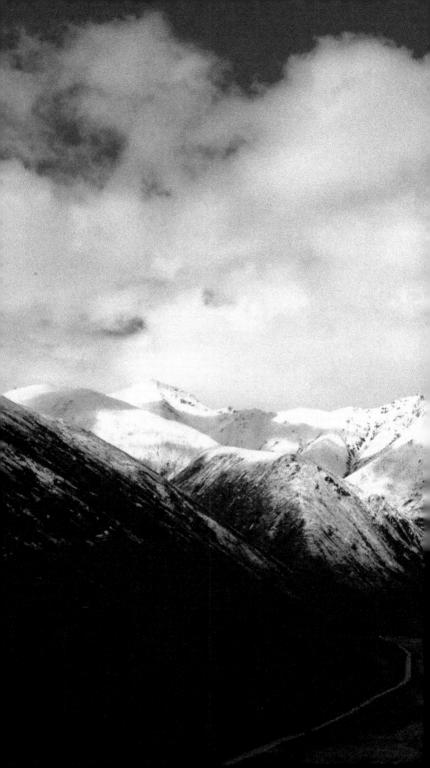

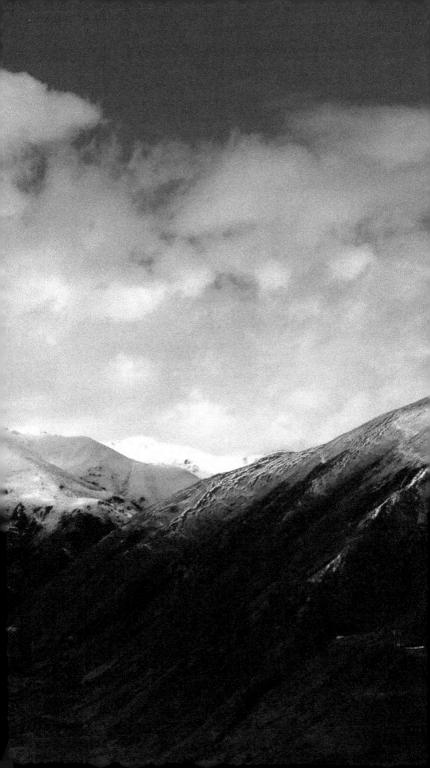

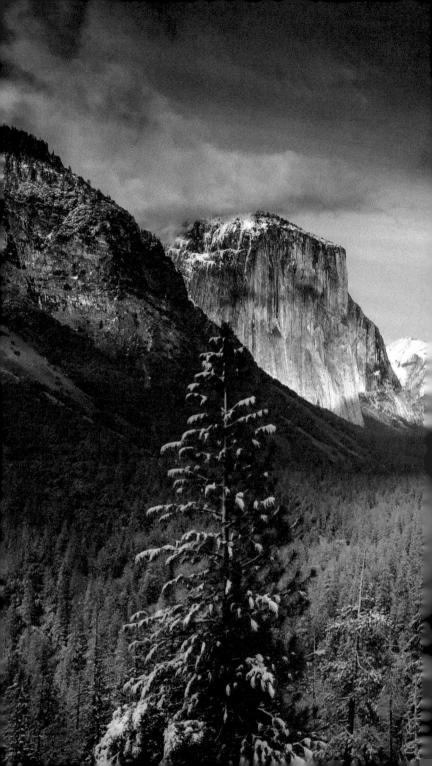

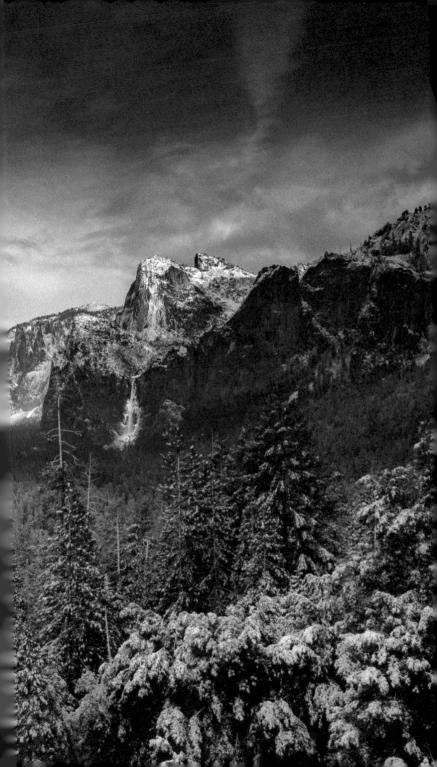

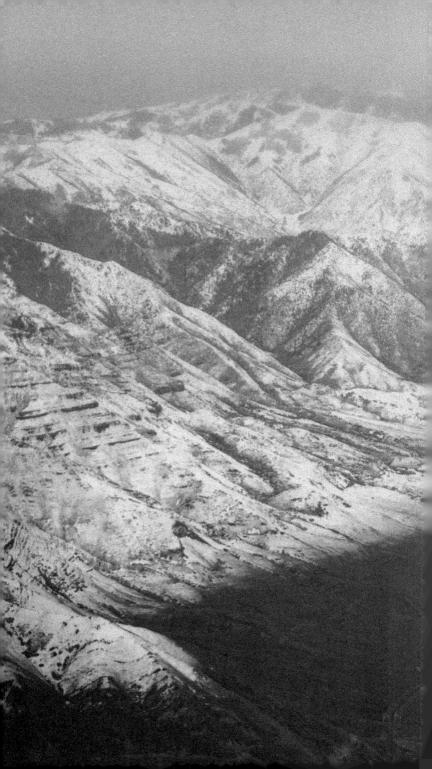

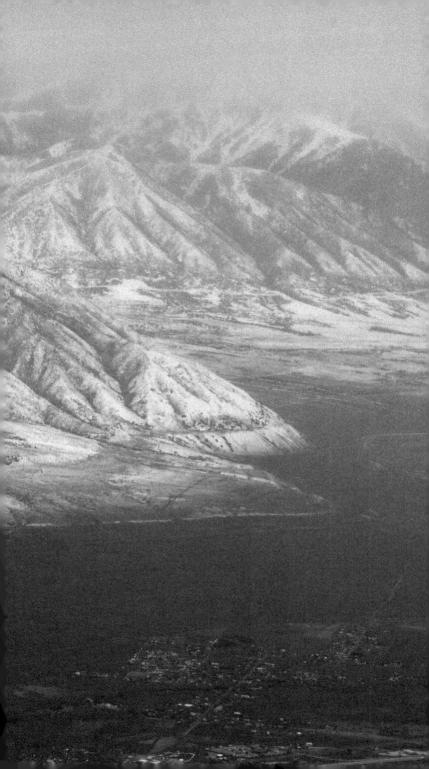

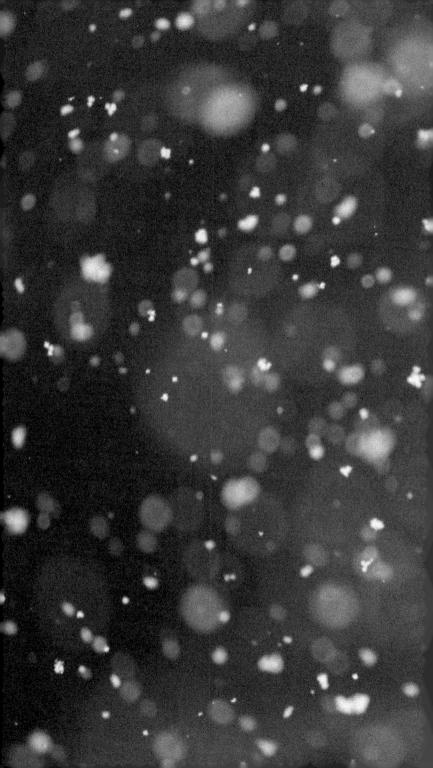

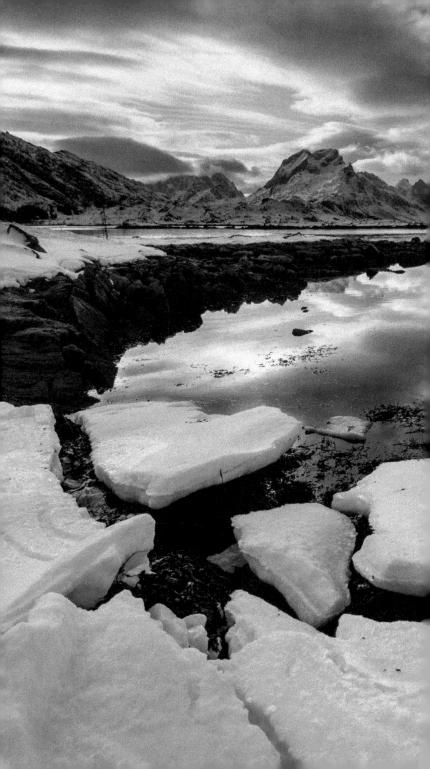

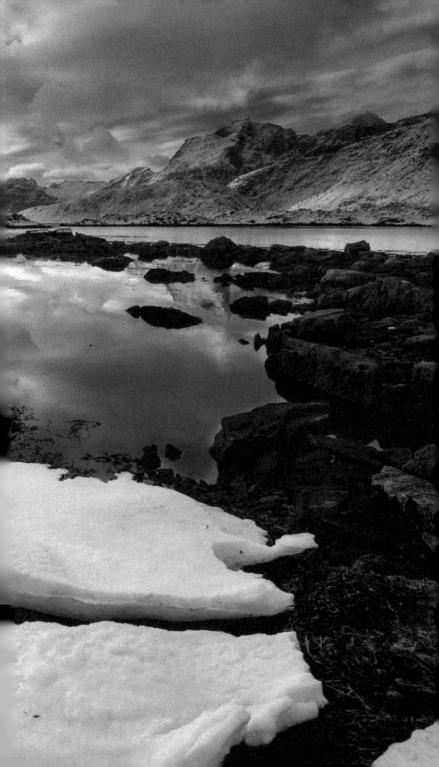

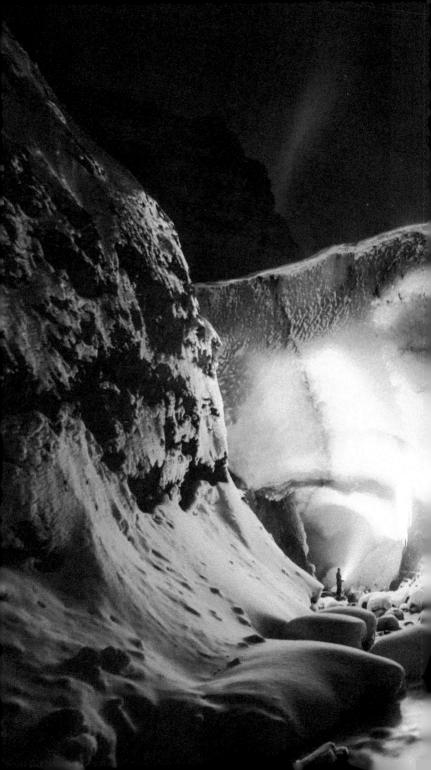

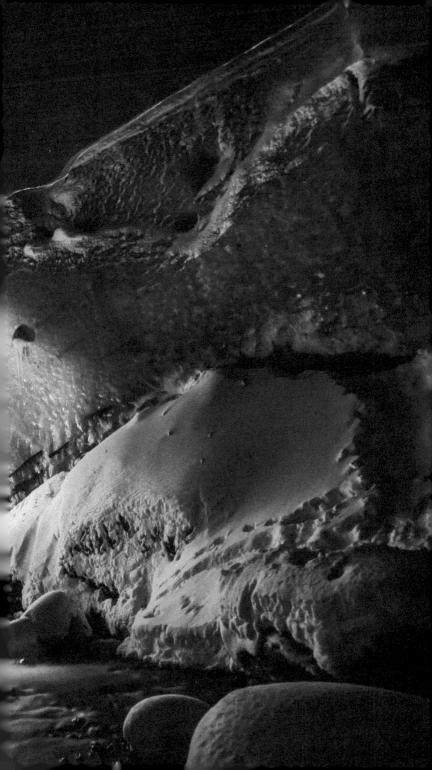

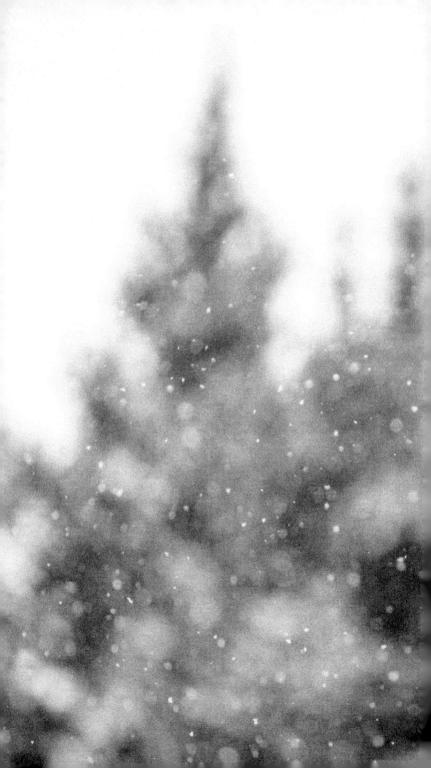

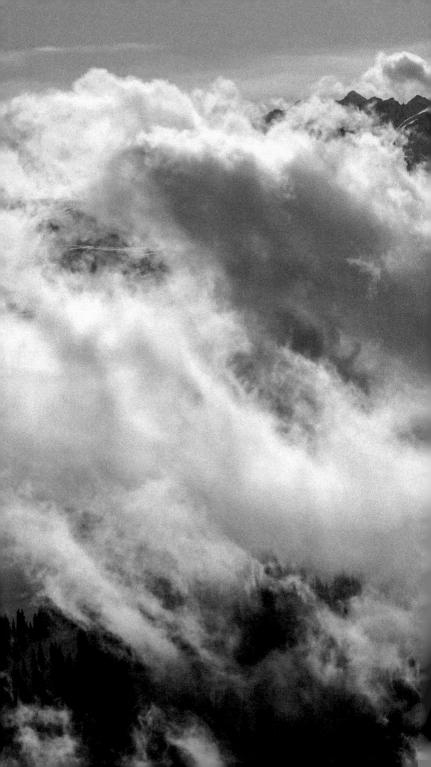

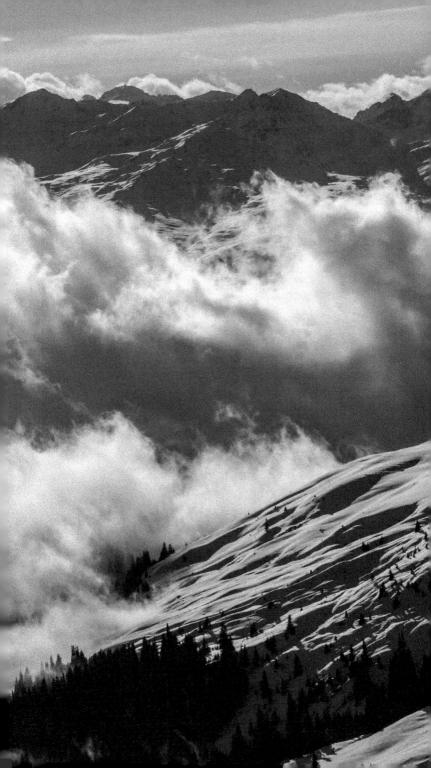

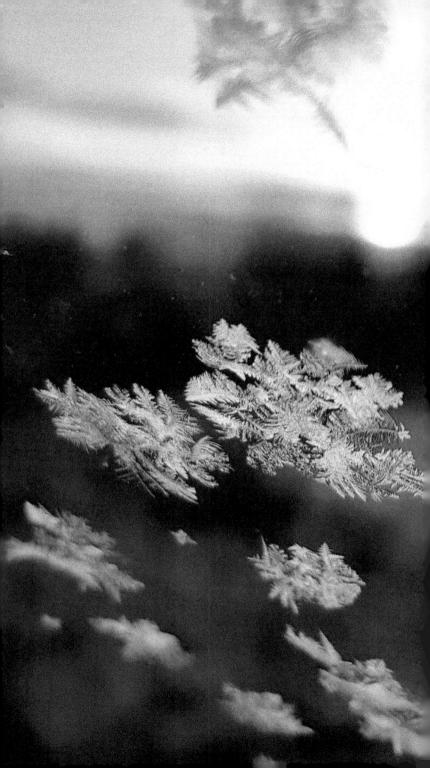

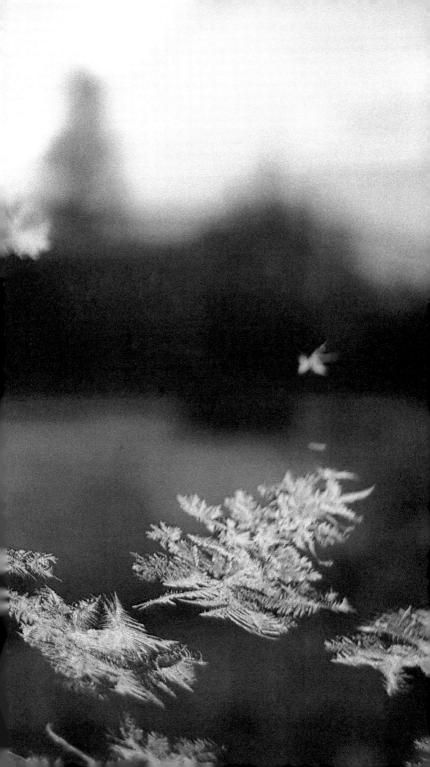

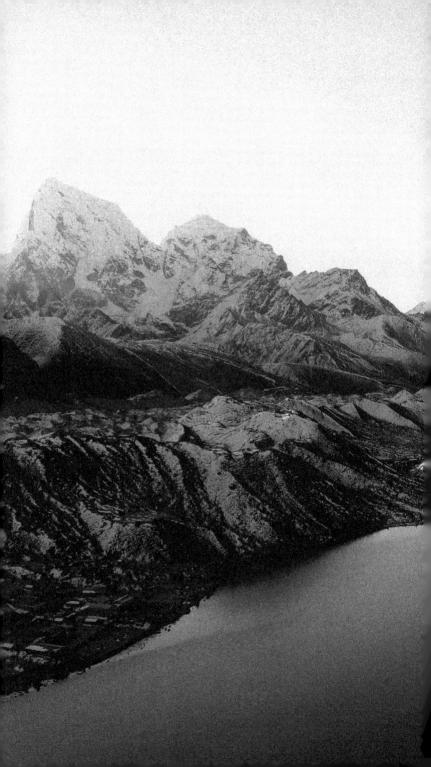

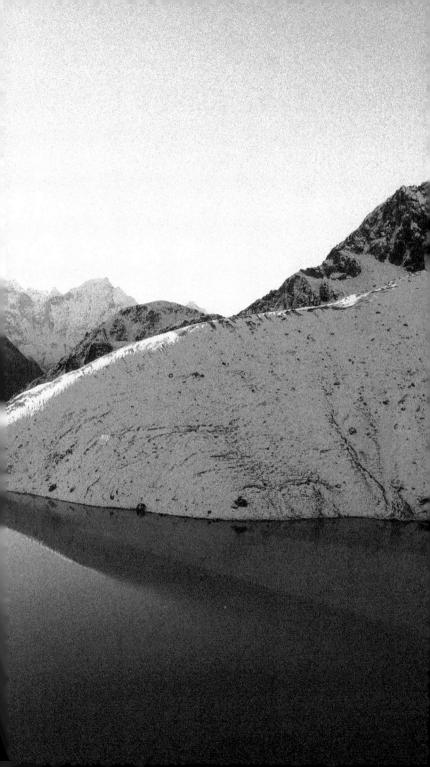

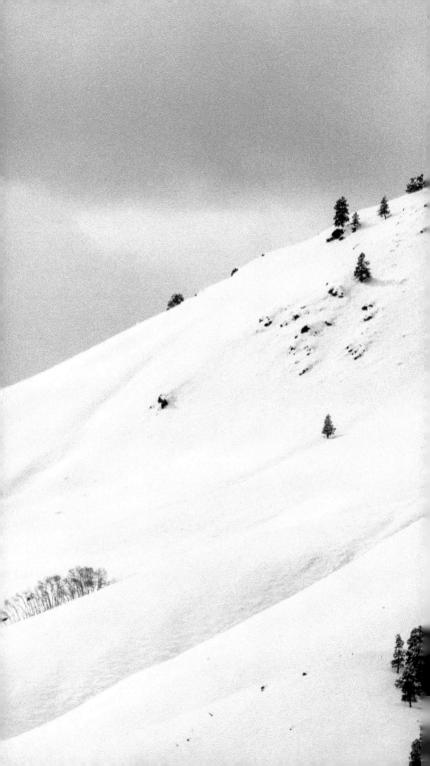

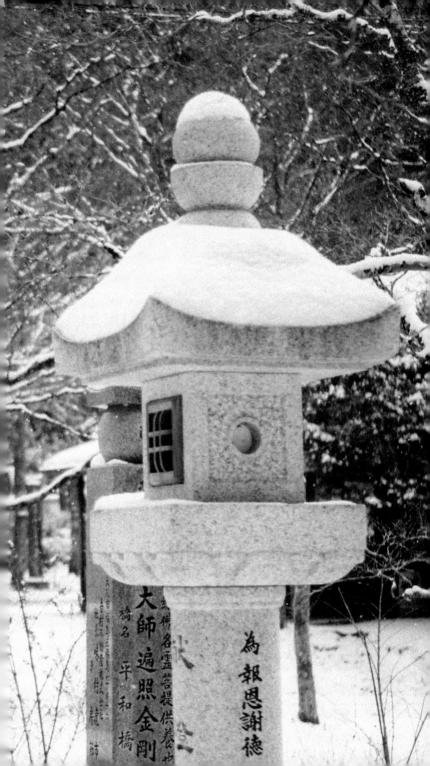

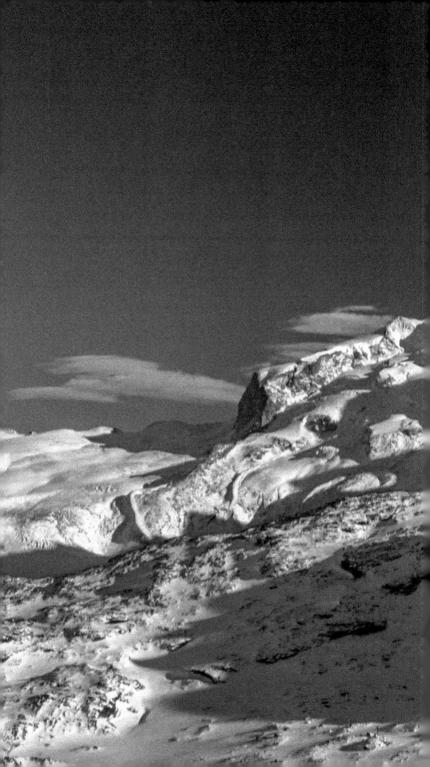

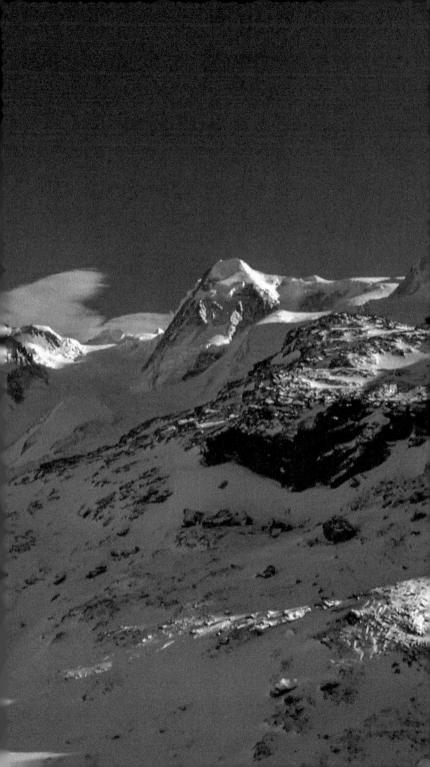

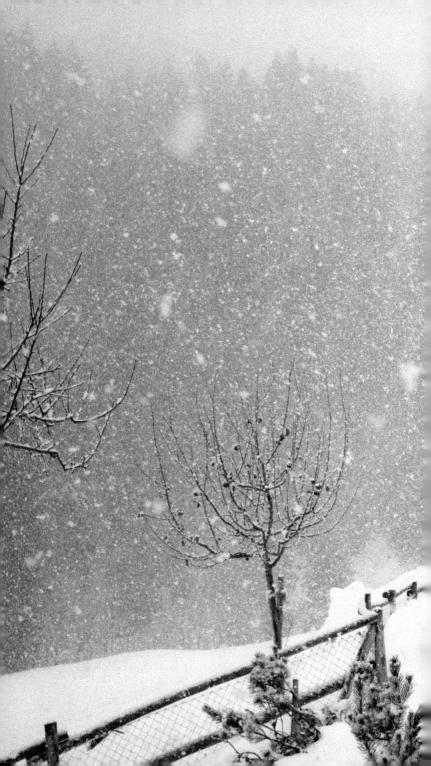

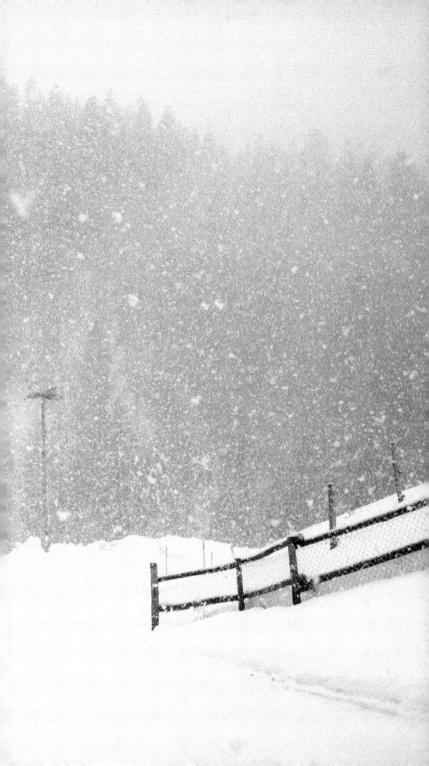

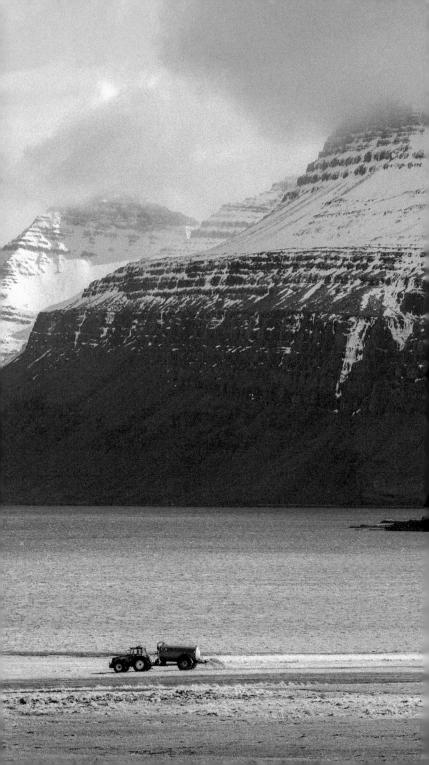

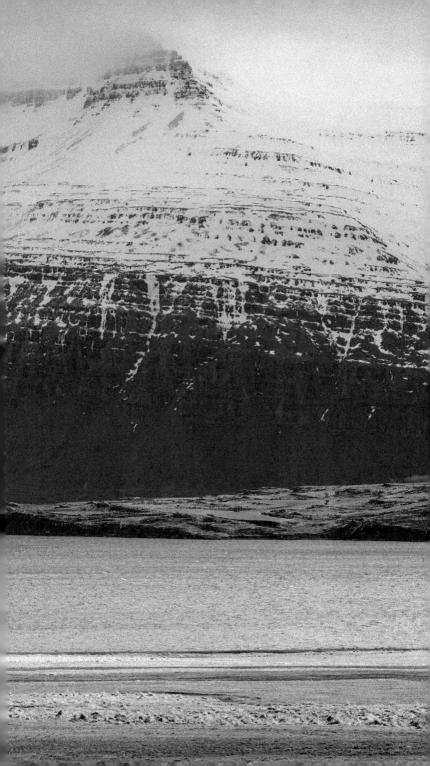

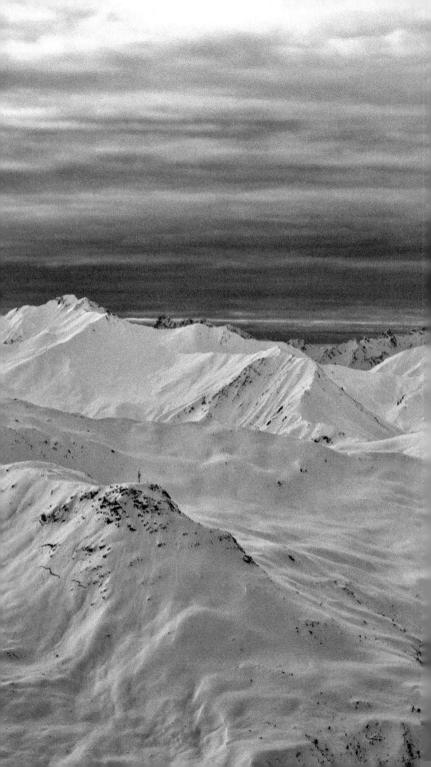

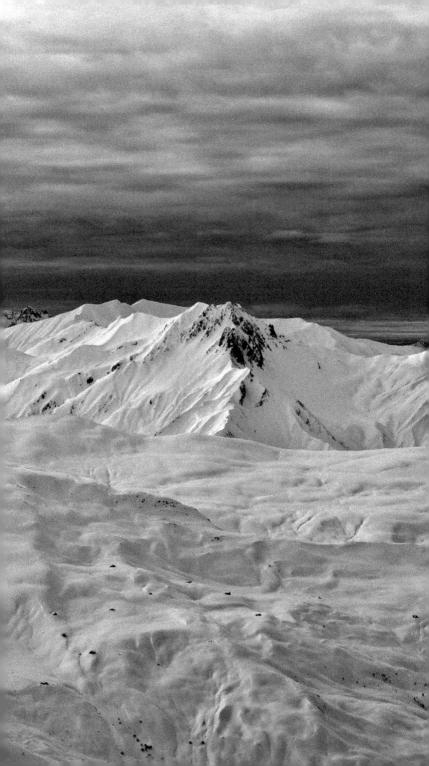

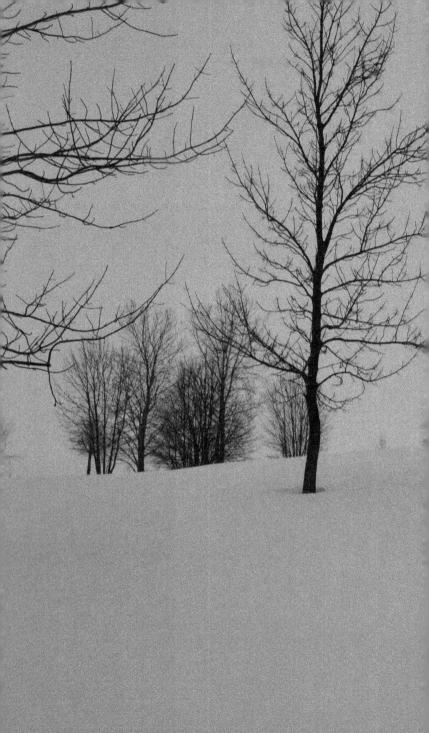

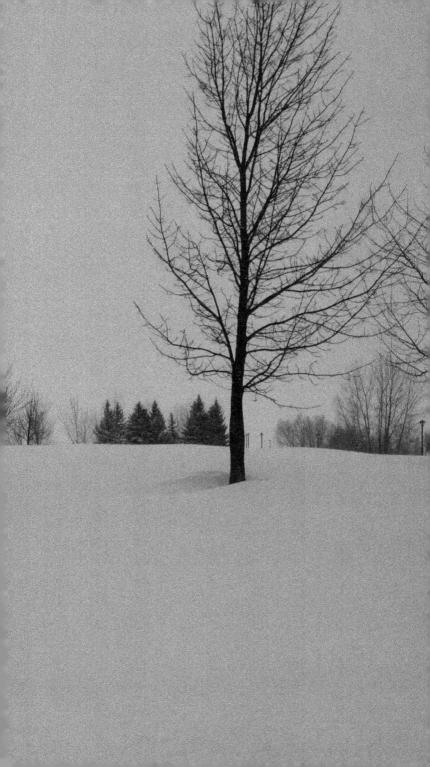

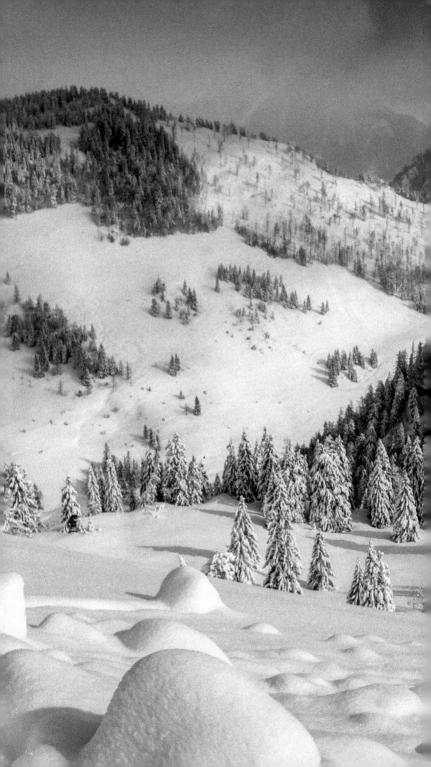

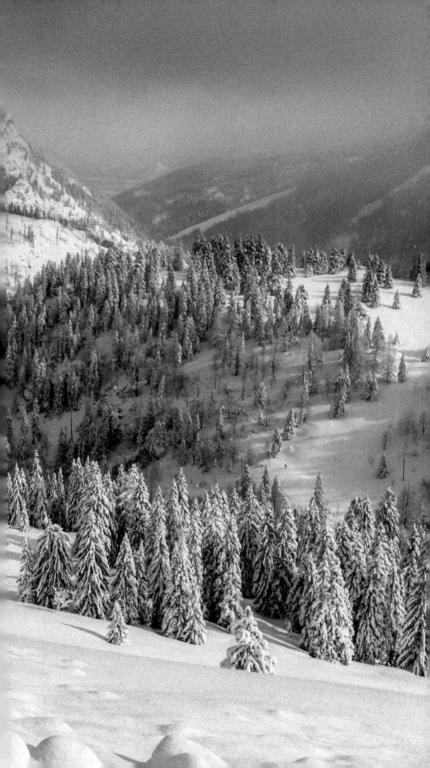

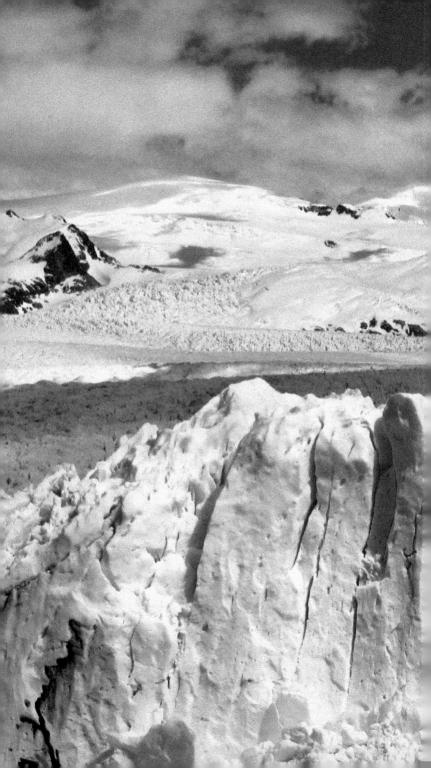

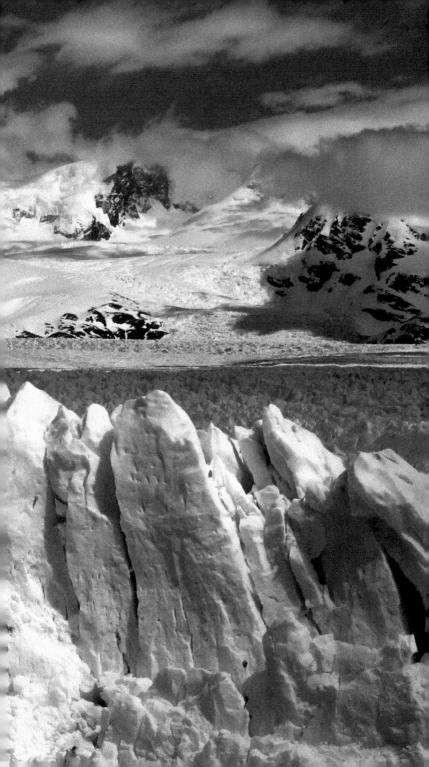

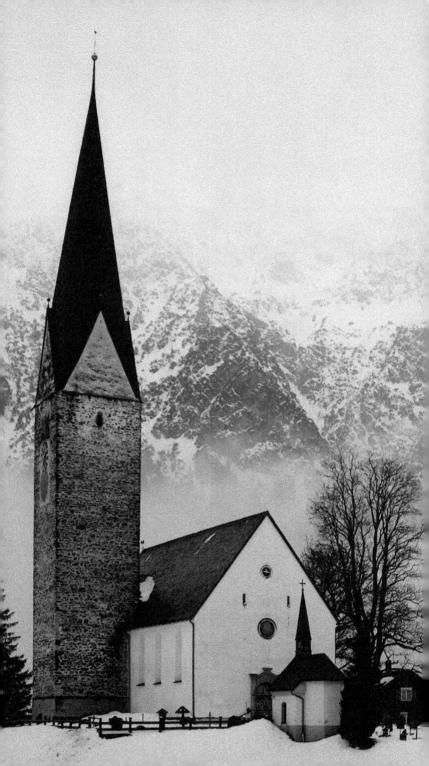

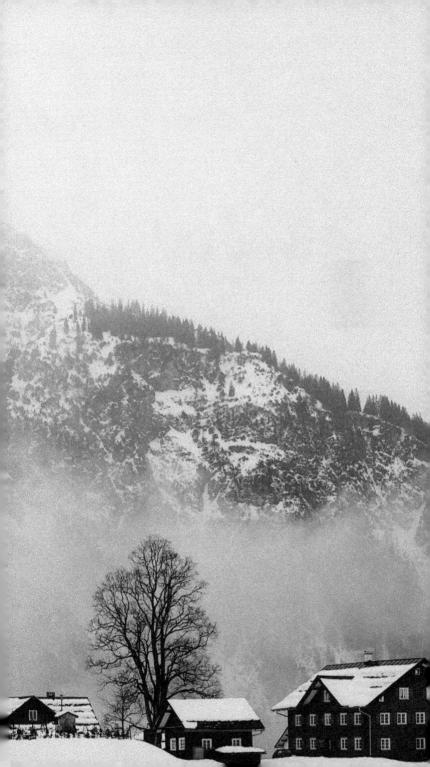

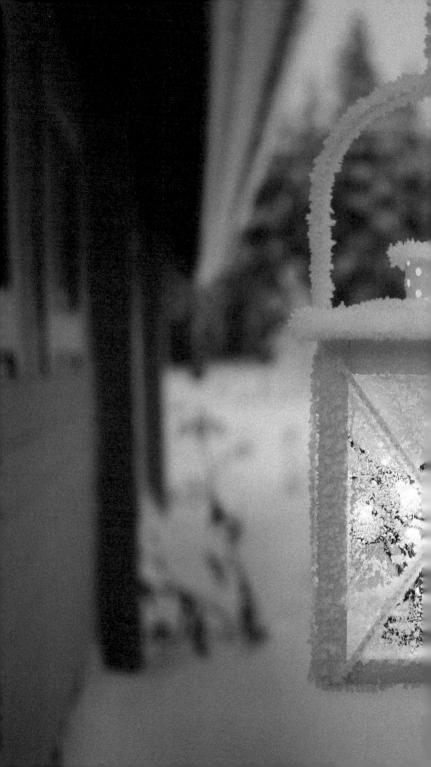

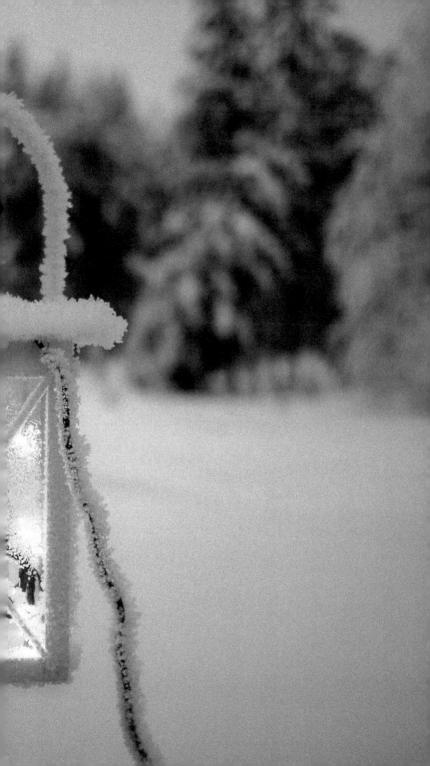

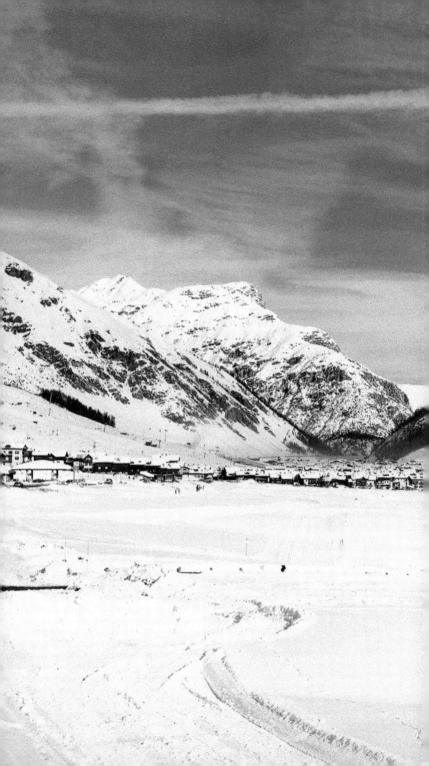

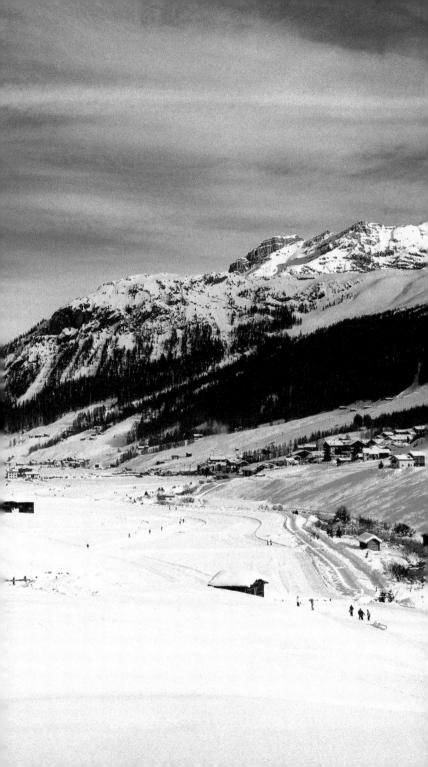

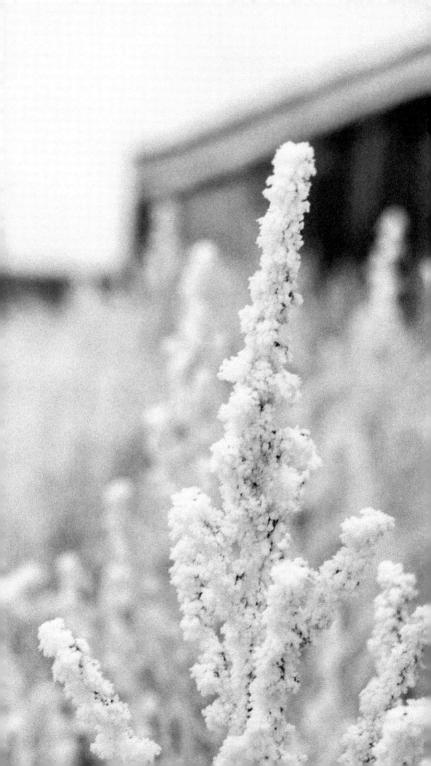

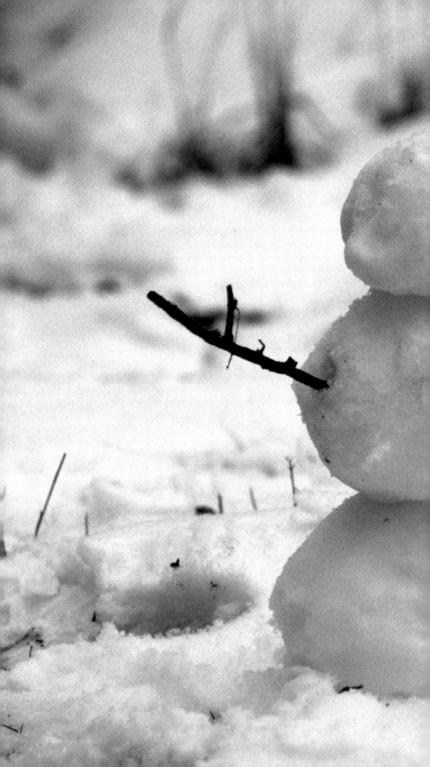

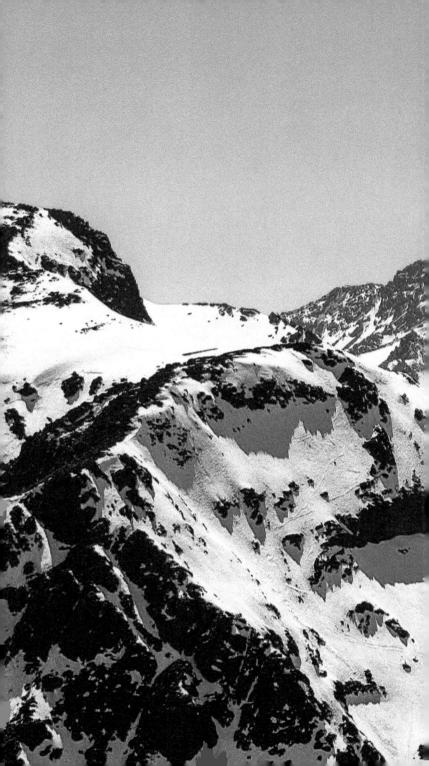

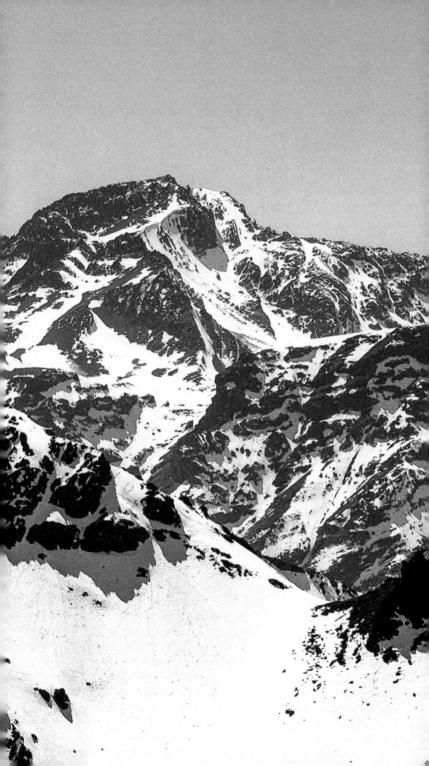

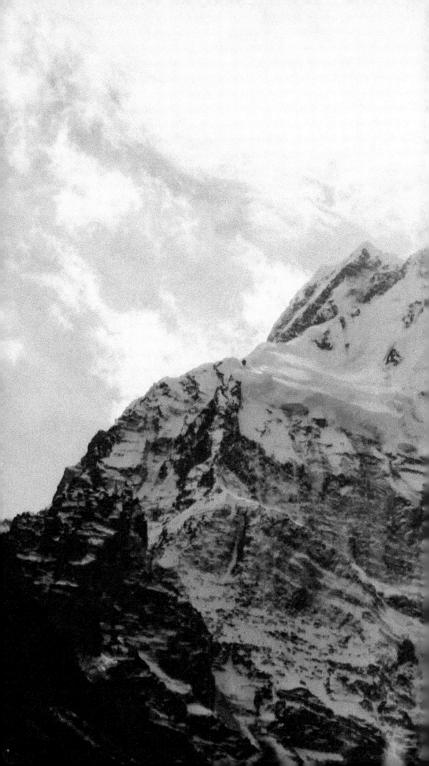

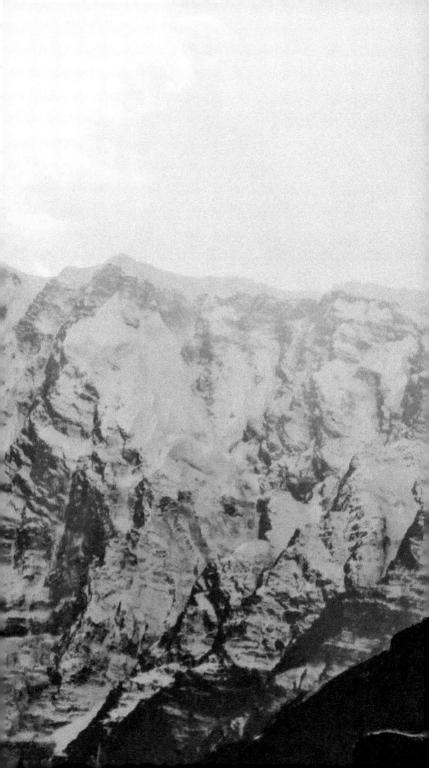

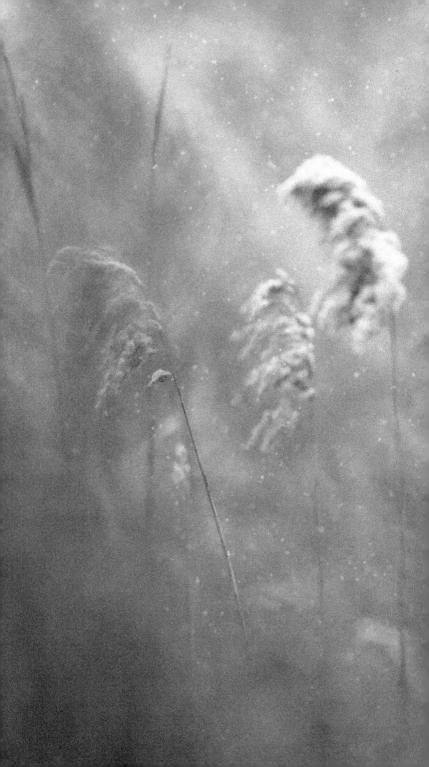

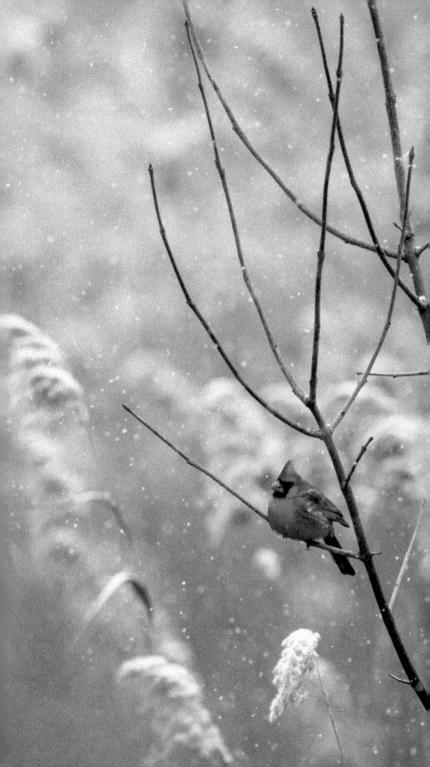

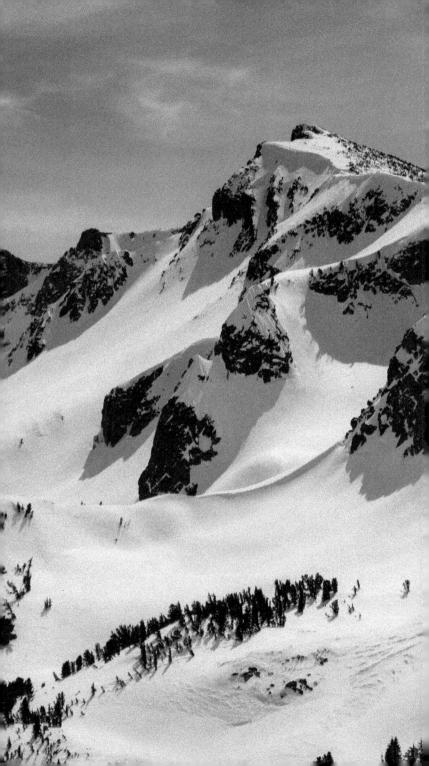

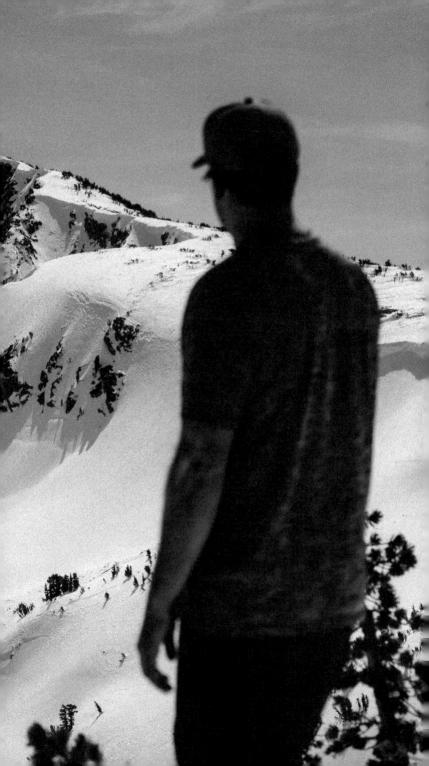

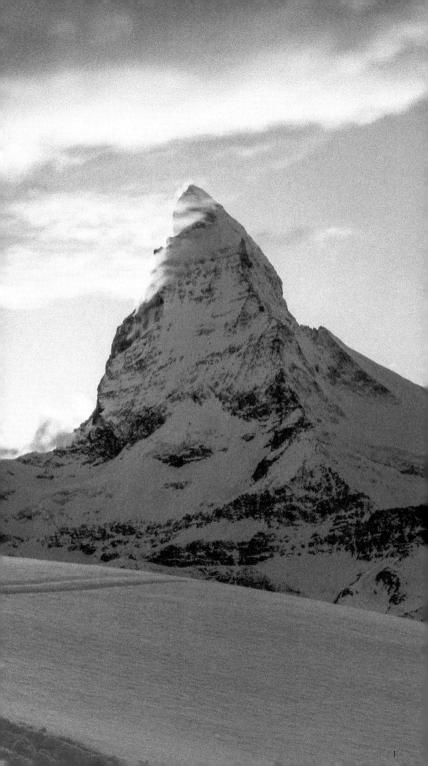

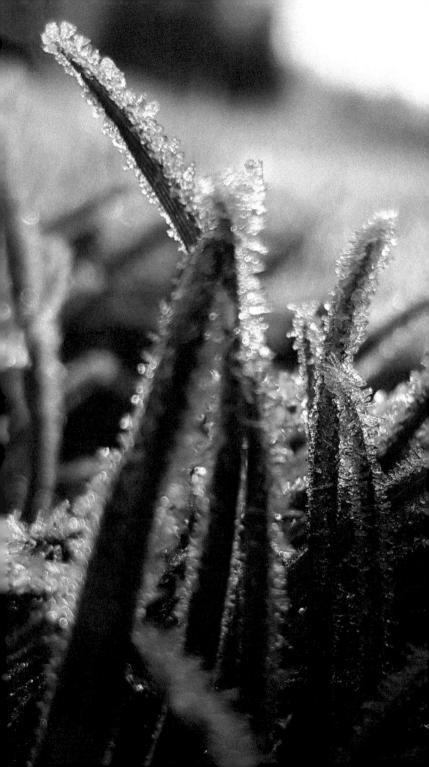

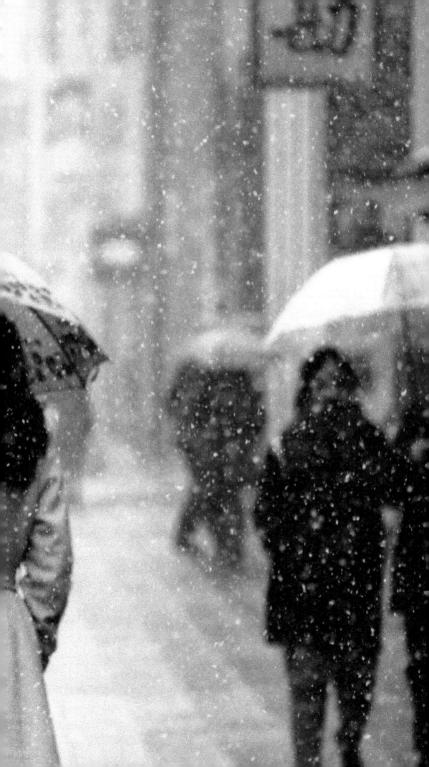

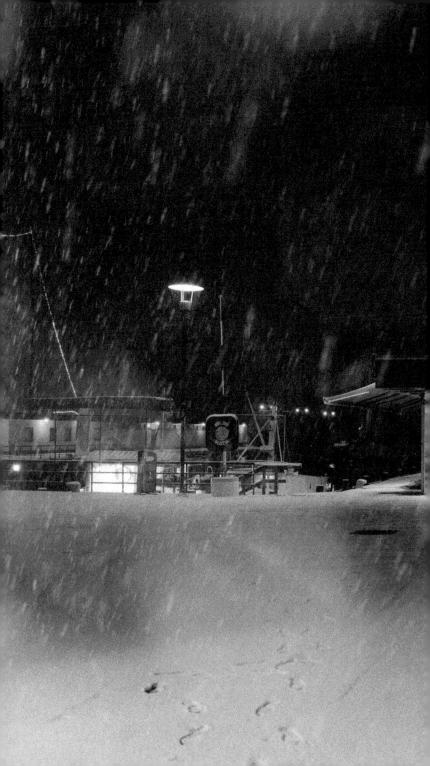

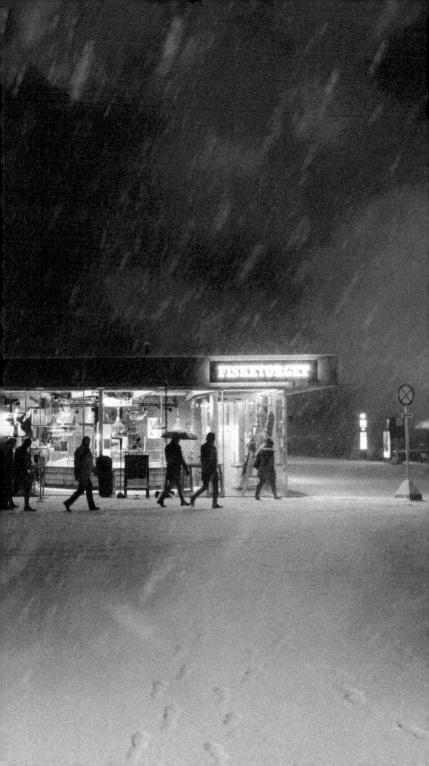

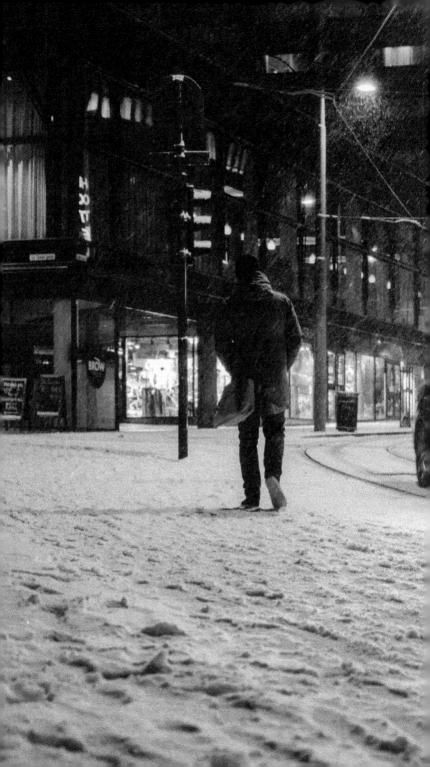

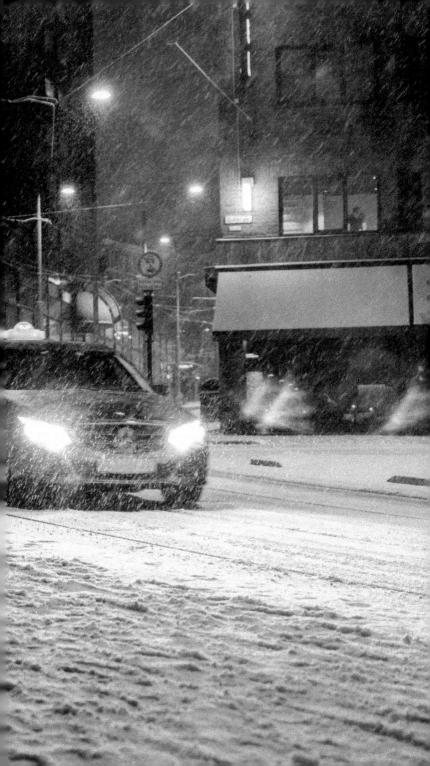

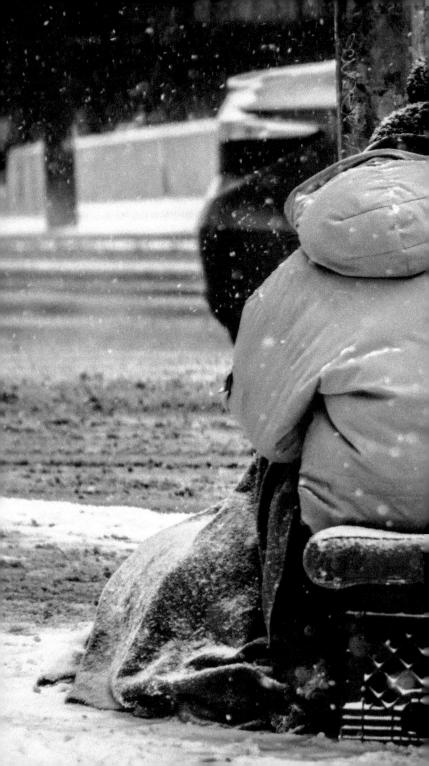

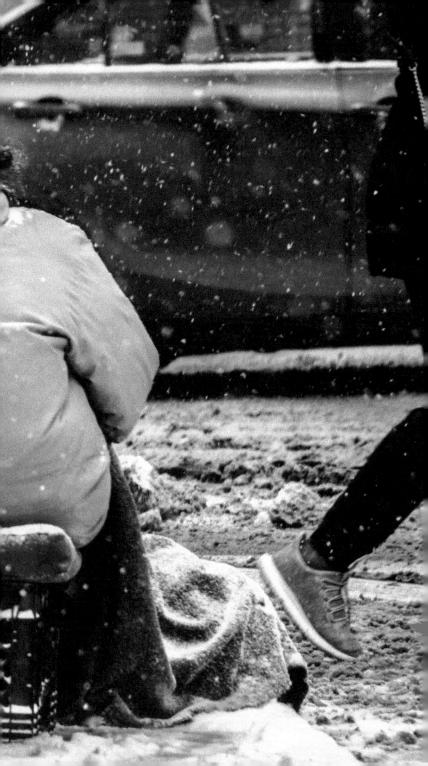

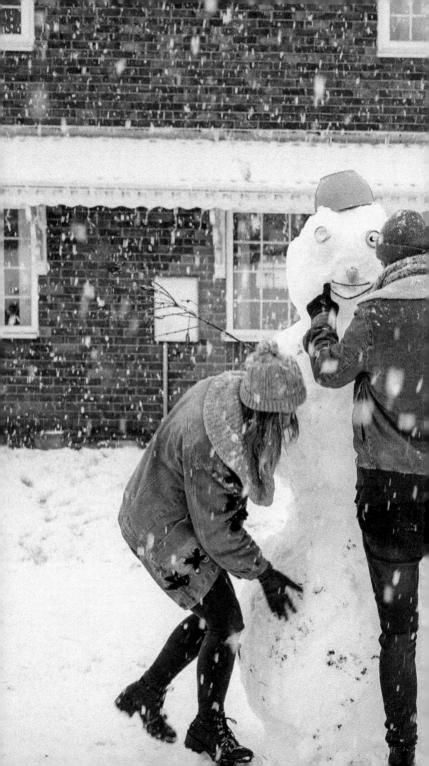

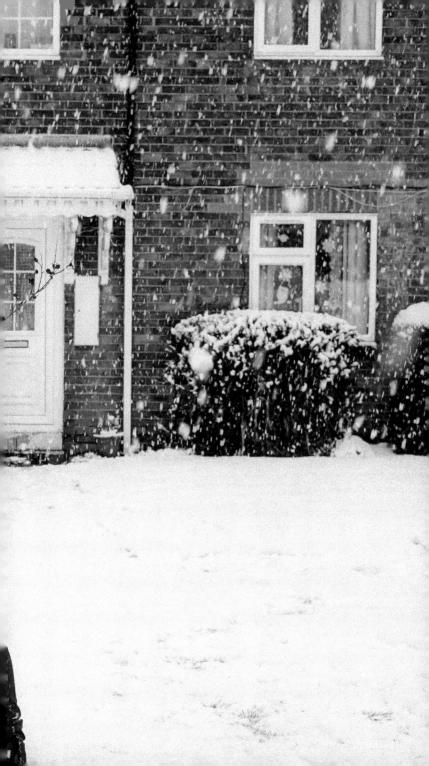

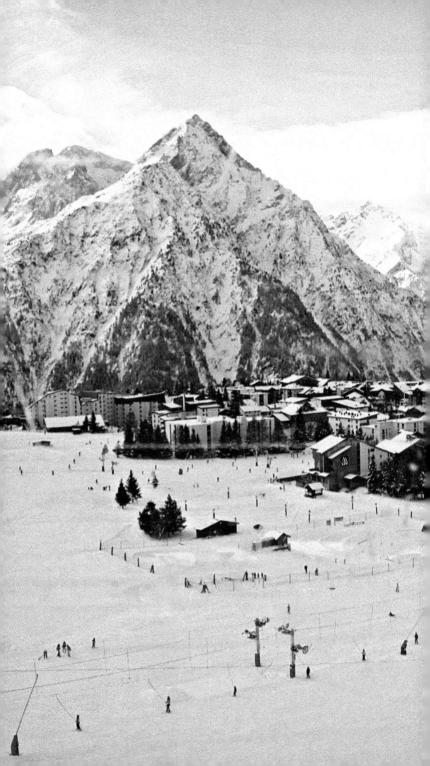

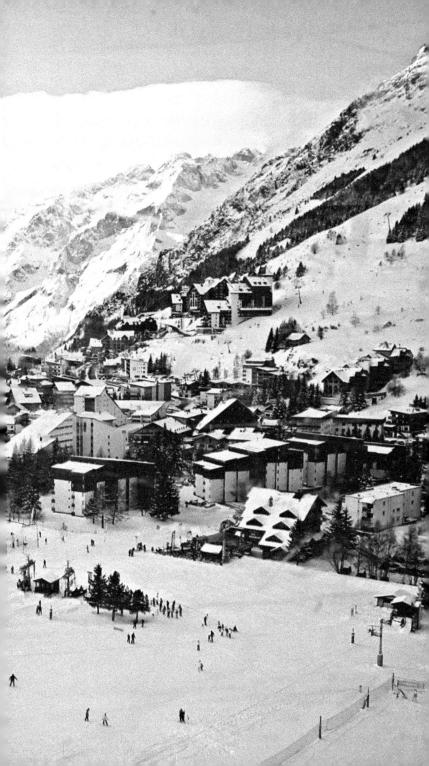

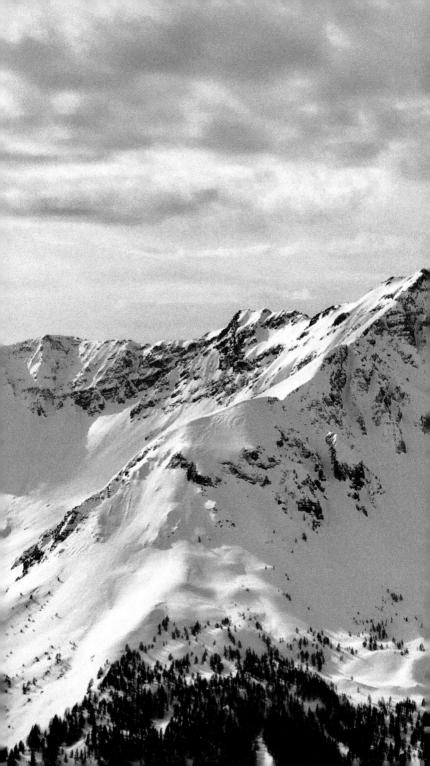

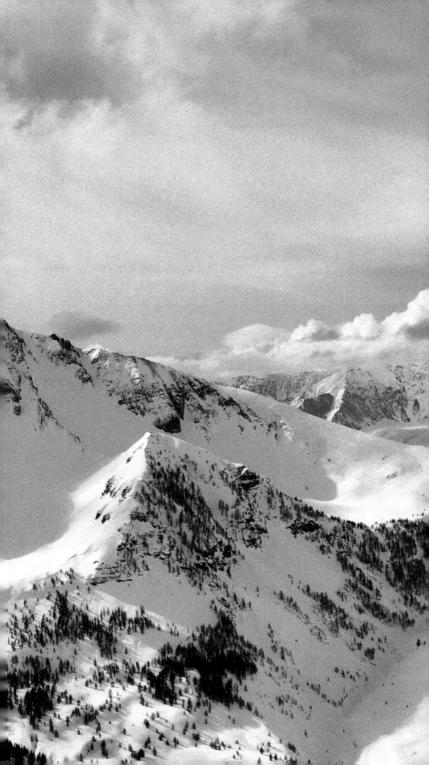

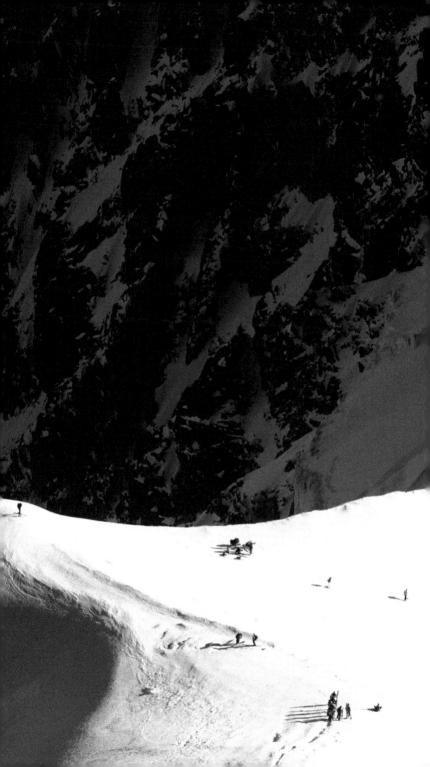

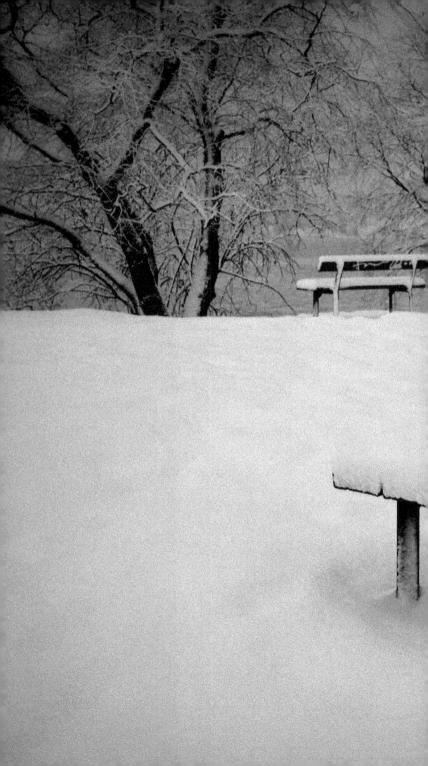

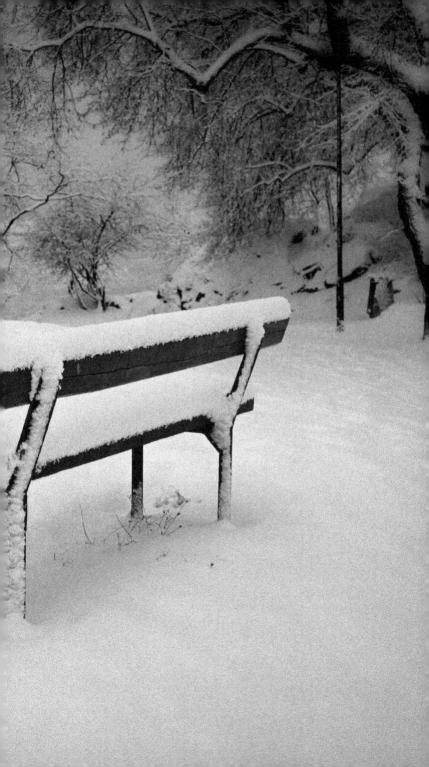

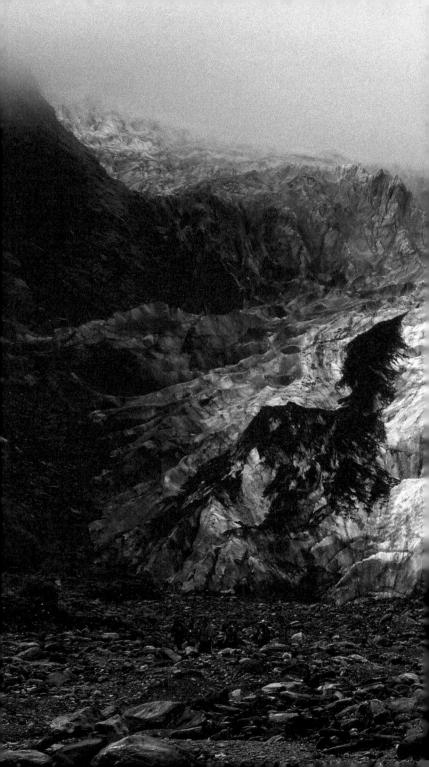

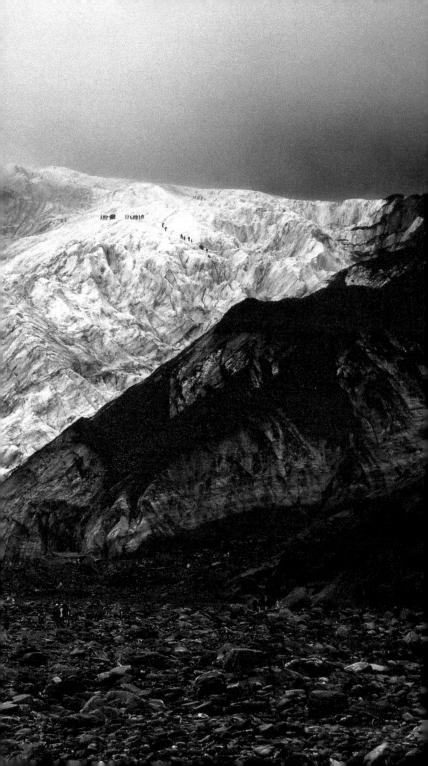

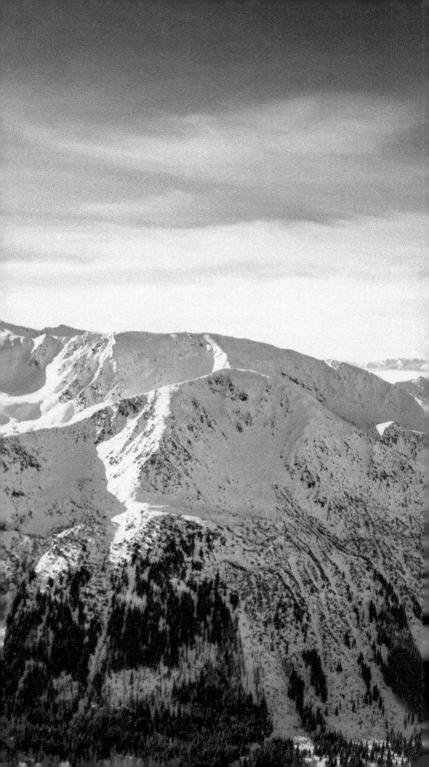

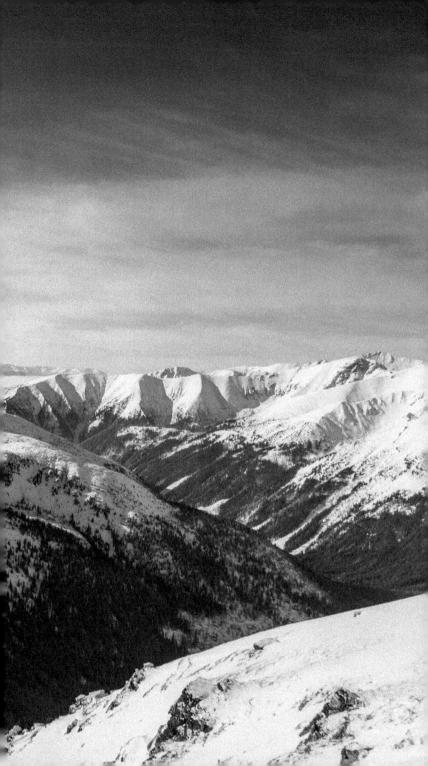

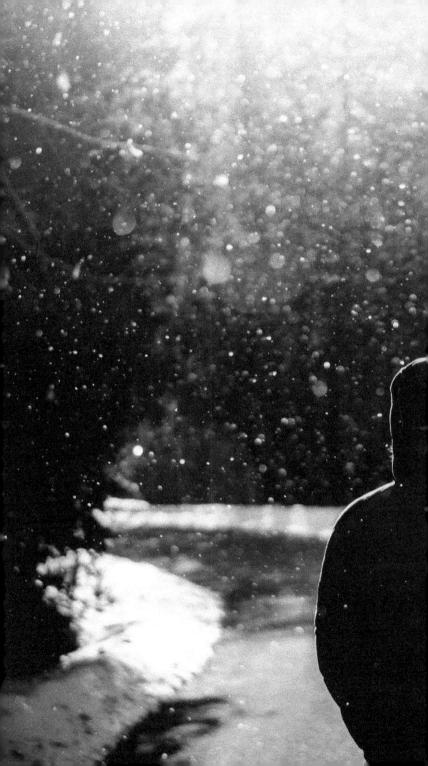

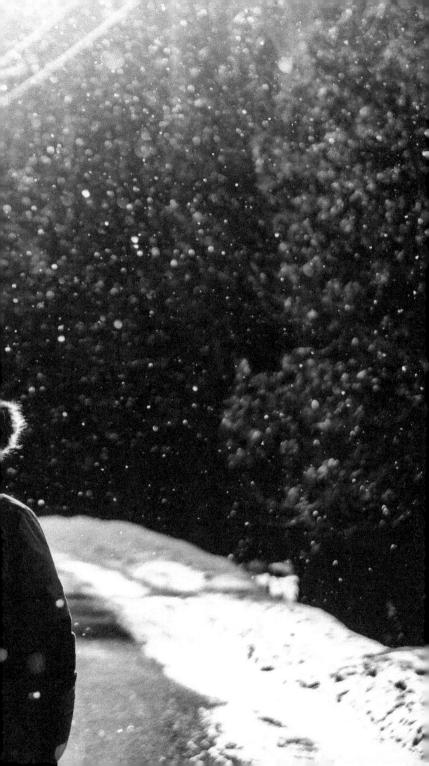

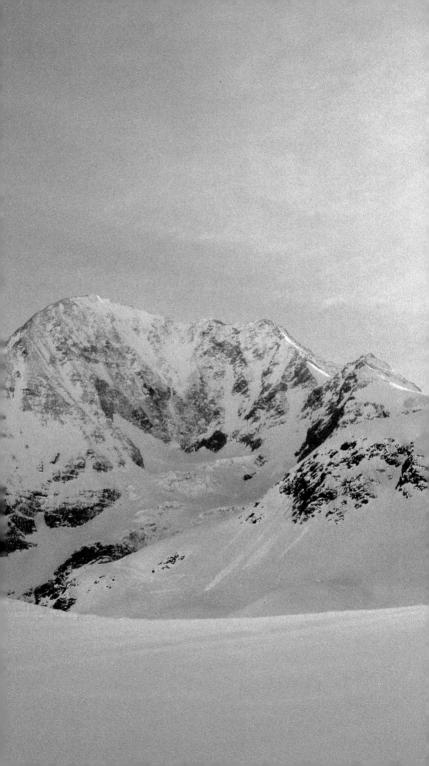

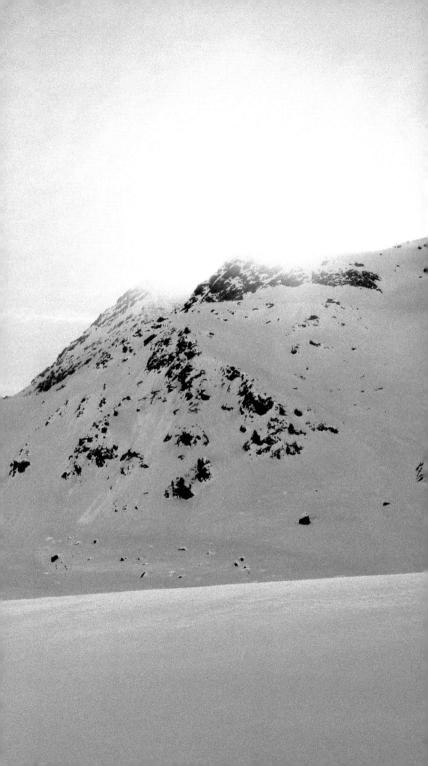

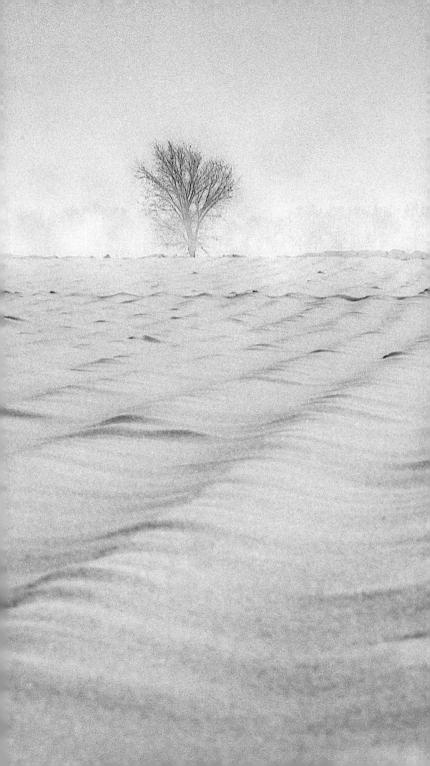

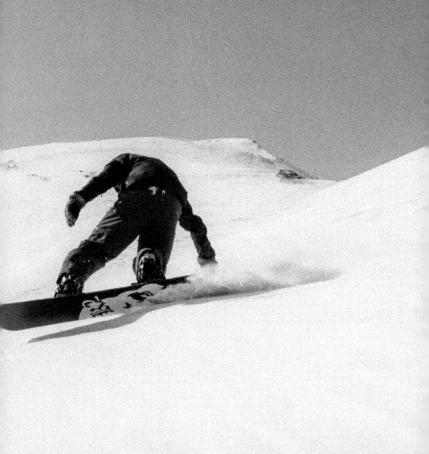

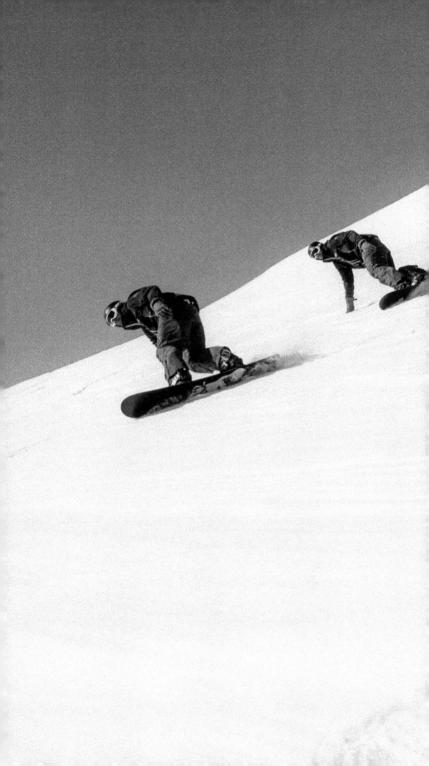

CPSIA information can be obtained at www.ICGtesting.com Printed in the USA BVHW052234160819 556069BV00014B/291/P